D0885712

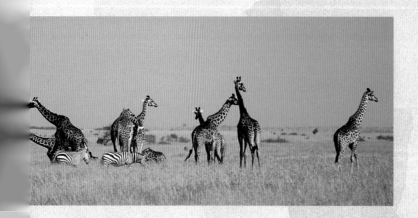

Map symbols

 Lodges or hotels

Camp sites

—— Highways or main roads

— Secondary routes (4x4)

National parks and reserves

Contents

Key to photo symbols

Wide angle lens: from 20 to 35mm

Medium focus lens: from 70 to 300mm

Long focus or telephoto lens:
from 400 to 600mm

Lake
Baringo

Lake
Bogoria

Nakuru

Nakuru
National Park

Naivasha

Mara River

Narok

Masai Mara
National Reserve

TANZANIA

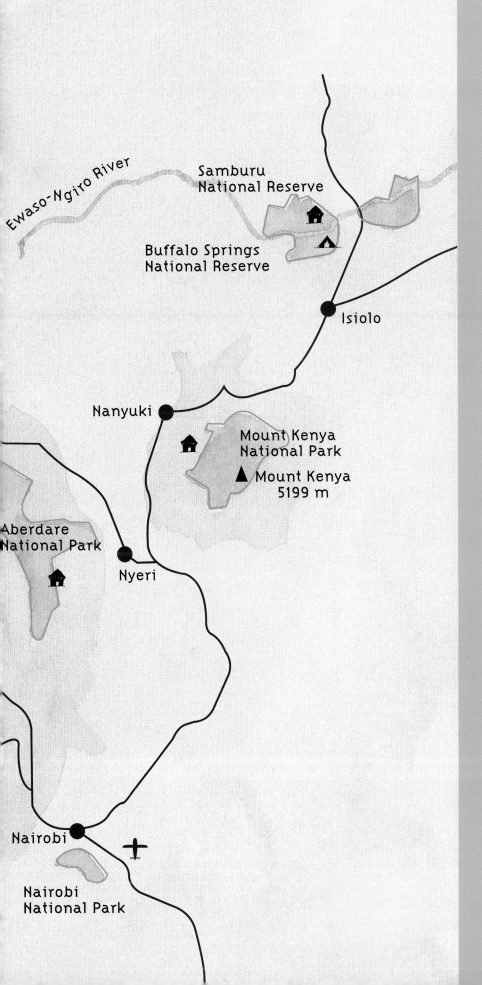

Ewaso-Ngiro River

Samburu
National Reserve

Buffalo Springs
National Reserve

Isiolo

Nanyuki

Mount Kenya
National Park
▲ Mount Kenya
5199 m

Aberdare
National Park

Nyeri

Nairobi

Nairobi
National Park

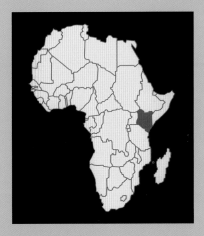

The worldwide success of the 1985 film Out of Africa, based on the life of Karen Blixen, helped to fuel the world's infatuation with Kenya for nearly two decades. As the primary tourist country in Africa, Kenya is renowned as a safari destination. The wealth of landscapes and wildlife attracts several hundred thousand visitors each year. They come to explore this paradise of golden savannahs, dormant volcanoes, shimmering lakes and heavenly beaches. Kenya is, unfortunately, a victim of its own success, with the environment being increasingly threatened. It is to be hoped that the Kenyan government will take the measures needed to preserve this special natural heritage.

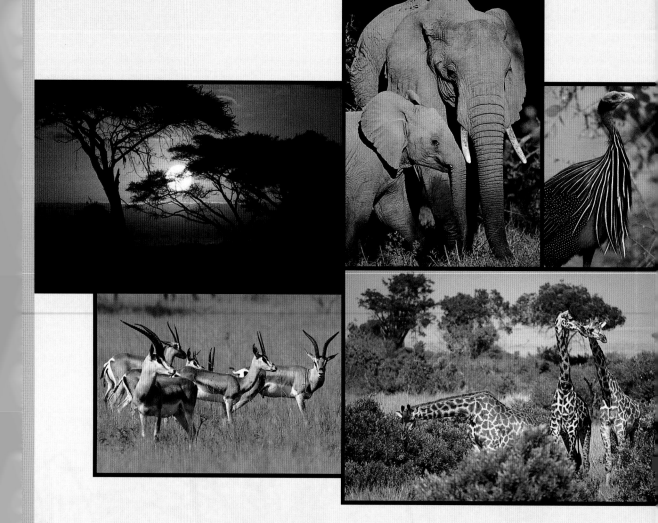

A British colony until 1963, Kenya is now an independent state with around 30 million inhabitants: a veritable diversity of peoples, with more than 40 different ethnic groups spread across a territory scarcely larger than France. Straddling the equator at the geographical centre of eastern Africa, Kenya lies to the south of the Horn of Africa. It shares borders to the north with Ethiopia and Sudan, with Somalia to the east, Tanzania to the south, and Uganda to the west. The monsoons which dominate the climate around the Indian Ocean have little effect on the East African climate, because the highlands inland modify the seasonal winds. The mountains and high plateaus enjoy a temperate climate, but lower down, the coast has a hot and humid climate influenced by the equator. The east and north of the country are the hottest and most arid zones. The Kenyan climate experiences two rainy seasons. The first, more copious one, is from March to June, and leads into the coolest quarter of the year. The second, more modest, is in November and December, leading into the hottest months. Kenya's physical setting is characterised by the presence of the Great East African Rift Valley. This monumental fracture of the Earth's crust, stretching over 6,000 kilometres, from the Red Sea to Mozambique, was created by earth movements millions of years ago.

The jumbled relief is punctuated by volcanic cones, steep escarpments and valleys dotted with a string of alkaline lakes, their charm in large part due to the region's ongoing volcanic activity.

Kenya can be divided into various geographical regions. To the southeast lies

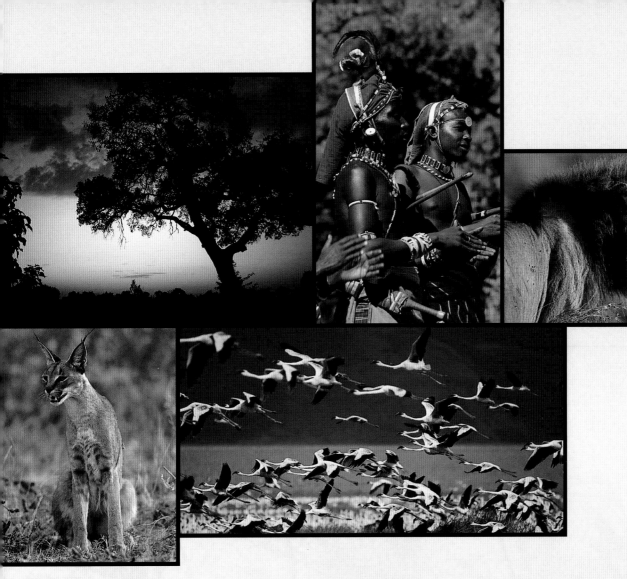

the coastal plain, with marshes running
inland to join an arid plateau with an
altitude of 1,300-2,200 metres. Rising
towards the east, the fertile Rift Valley
forms a jigsawpuzzle of lakes, extinct
volcanoes and hot springs. Its eastern flank
is spiked with mountains, dominated by
Mount Elgon, the second-highest peak in
the country after Mount Kenya. In the west,
rolling highlands that cover a quarter of the
country slope gently down towards Lake
Victoria. The wild spaces between forests
and grazing land accommodate the Masai
Mara National Reserve, as well as Amboseli
and Tsavo National Parks, while to the north
lie the uncultivated plains around the hostile
Chalbi Desert.

Dominated by savannahs, Kenya's
enchanting landscapes are a refuge for
particularly abundant and varied wildlife.

Sharing their territory with the large
predators, 90 species of ungulates –
including 70 varieties of antelope – live off
the long, rolling plains, beside open wood-
land, silvery rivers, and green hills. With
1,500 species of birds, Kenya is a Mecca for
ornithologists. Many migratory birds from
distant northern countries make their winter
quarters here. The choice of locations pre-
sented in this book was made by seeking to
get away from the more traditional circuits.
We begin with the mountainous Samburu
National Reserve, before taking you along
the Great Rift Valley to discover the magical
waters of Lakes Nakuru, Bogoria, and
Baringo glittering in the valley bottoms,
enclosed by sculpted cliffs and well-rounded
hills. We end our tour by visiting the
prestigious and unmissable Masai Mara
National Reserve.

 Whatever the season, a river is always the heart of any reserve. Concentrating your attention on its banks is the most reliable way to spot wildlife coming to bathe, to shower, or to drink. Elephants need a lot of water, so they have to visit the waterholes several times a day. Here a lone adult, taken with a wide angle to show its surroundings, the richness of the riverine forest, and the size of the river, gives a good idea of what it must be like when the waters are high.

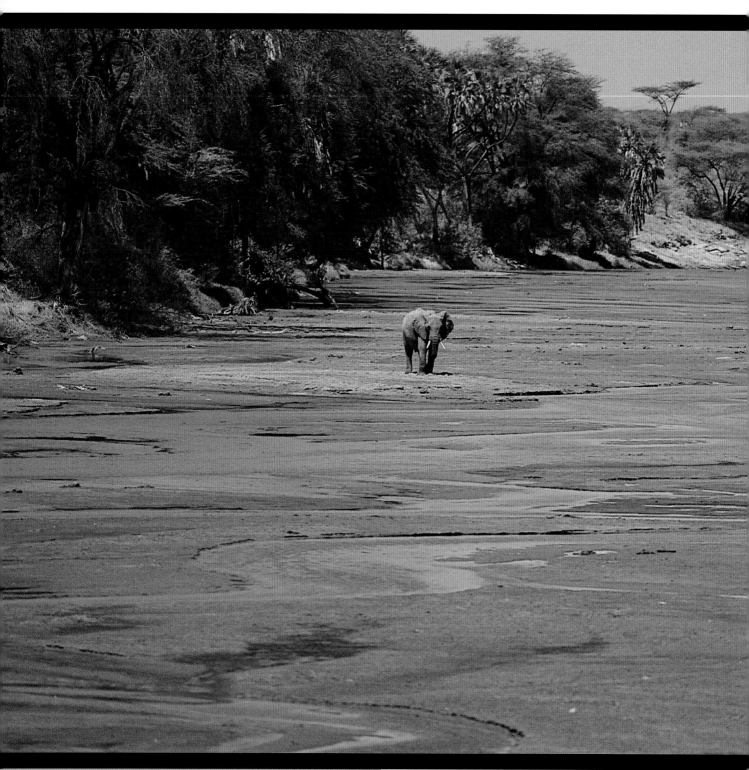

Samburu

Samburu National Reserve was set up in 1962 on the north bank of the Ewaso-Ngiro River. It adjoins the Buffalo Springs National Reserve established two years later on its south bank, though these two protected spaces are regarded as a single entity. Linked by a bridge, together they cover an area of around 500 square kilometres in the geographical centre of Kenya, at an altitude of around 1,300 metres, on the fringes of the desert areas in the northern half of the country. The Ewaso-Ngiro originates in the foothills of the Aberdare Mountains, which are dominated by Ol Doinyo Lasatima rising to almost 4,000 metres, but is principally fed by the run-off waters from Mount Kenya. This natural asset guarantees a constant water supply for the wildlife as well as watering a superb gallery forest, a ribbon of greenery bordering the river's broad meanders. But the two reserves mainly consist of wooded steppe where the thorny vegetation is dominated by acacias. The north is a rockier world, the ochre relief rising into eroded hills and hollowed out by twisting gorges, whilst in the damper south there are many marshy

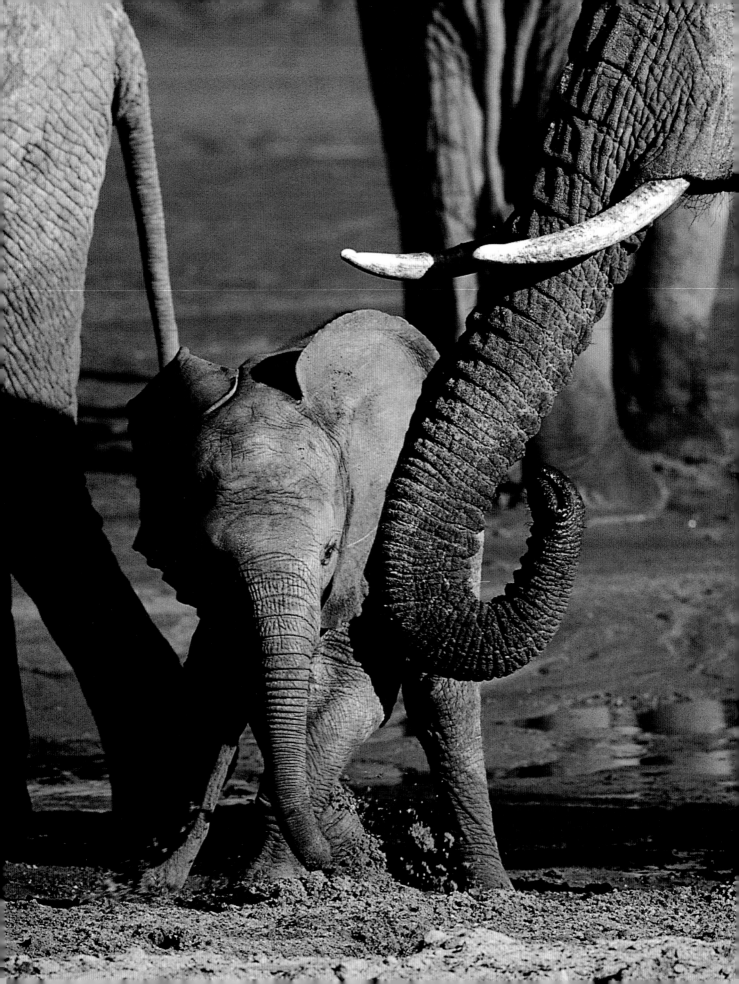

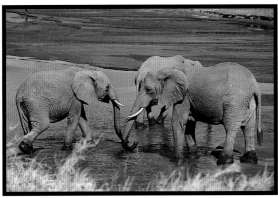

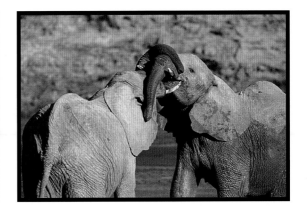

Elephants move around as a family unit, so all the individuals within a herd are related. There is a dominant female – the matriarch – and other females, along with several generations of youngsters. Just like all young animals, the elephant calves like play-fighting and imitating their elders. Sometimes they find a willing playmate, but now and then they find themselves brought firmly back into line. But each time, their mimicry and behaviour are an opportunity for fine pictures. The telephoto is very useful here because you should avoid the risk of being charged, by not getting too close to any herd.

areas. The placid waters of the Ewaso-Ngiro, which wind down from the wild Aberdare mountains, constitute a perennial river that supports luxuriant vegetation benefiting wildlife in general. Amid the arid, bare savannahs, the borders of the river lined by graceful doum palms and tamarinds constitute a veritable oasis. During the dry season, they are a bustling gathering-place for all the animal populations. Belching hippos and impassive crocodiles are equally at home in this aquatic environment. When the sky is solid blue and without any trace of clouds, the elephants gather each day around the puddles and residual channels of the river. But when the rains swell the course of the Ewaso-Ngiro and the vegetation regains its luxuriance, they swim across the river in search of new food supplies. Waterbuck also never stray very far from the life-giving water. They are constantly on the watch for the presence of lions that occasionally hunt zebra and impala here. A few discreet black rhinoceros share this

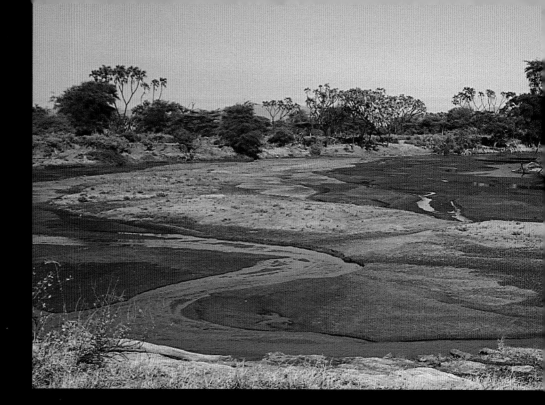

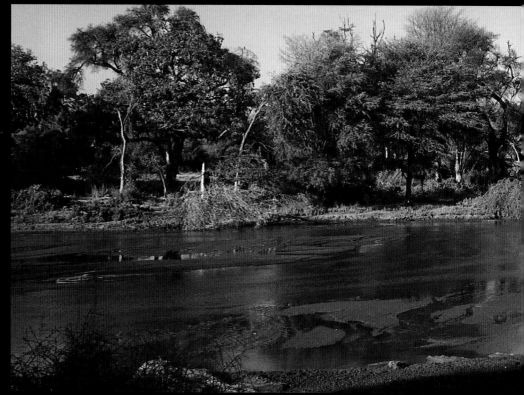

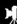

The Ewaso-Ngiro River is truly
the geographical heart of the
Samburu and Buffalo Springs
National Reserves, dividing them
into two areas of almost equal
size. Since the dawn of time its
waters, varying in volume
according to the season, have
been feeding a strip of forest
that lines its banks, the secretive
home of an impressive
concentration of animals. A wide
angle is most suitable both for
conveying the scale and showing
the broad river meanders with
their rich vegetation.

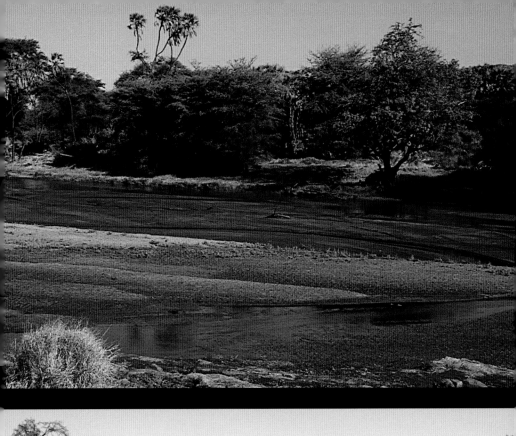

Beisa oryx are at home in
the arid bush savannah
within the north of Samburu.
Timid, they keep their
distance, obliging the
observer to use a long lens
to photograph their
bi-coloured faces and long,
ribbed horns. The same
lens was useful for this fine
portrait of a gerenuk.
In a light softly filtered by the
tree cover, its unusual, long-
necked physique occupies
the space strangely and is
quite tricky to photograph.

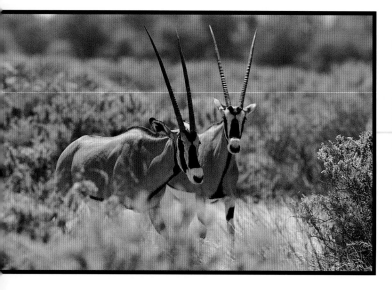

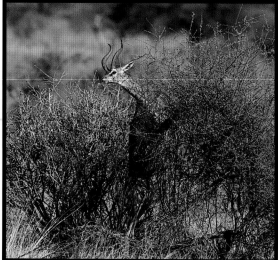

territory, the numbers of this curious and
fascinating animal reduced to a few individuals
by poaching. The Ewaso-Ngiro haven is also
renowned for good views of the reticulated
giraffe, majestic in its russet coat with geometric
patterns outlined perfectly by white markings.
The river bank forest provides plenty of hiding-
places for the silent leopard, which with its
disruptive markings, is hard to spot amongst
the dense foliage.

Among the commoner bird species, the
vulturine guinea fowl is noteworthy in its dark
grey livery with a pale mother-of-pearl sheen,
its breast ringed with long blue feathers.
The vegetation along the river banks has a
significant concentration of fauna, but the
surrounding areas — at the heart of each of the
two reserves — are nonetheless home to a host
of extremely varied species. Bristling with

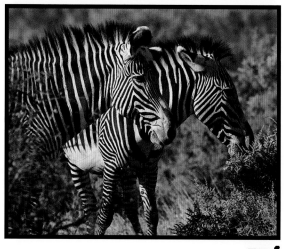

Samburu is one of the last
sanctuaries of the Grevy's zebra.
A long lens is recommended for
photographing these without
disturbing them, yet still
capturing the patterns of their
finely-striped coats. It is this coat
that distinguishes them from the
Burchell's zebra, as well as their
big, broad, round ears, and the
imposing size that makes them
the largest of wild equids.

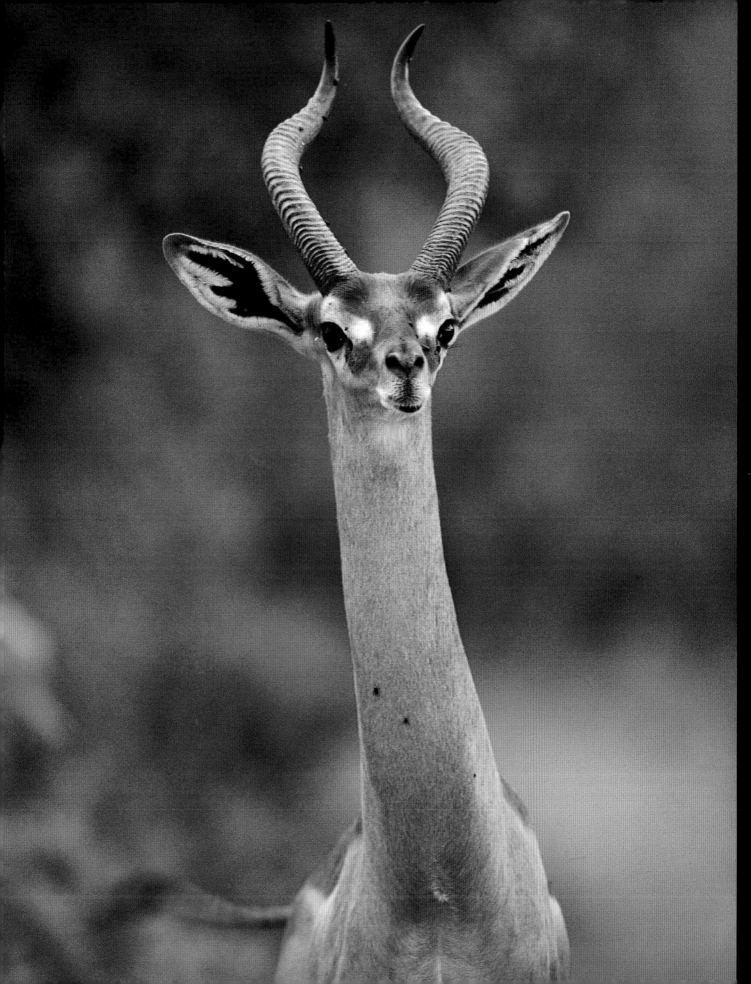

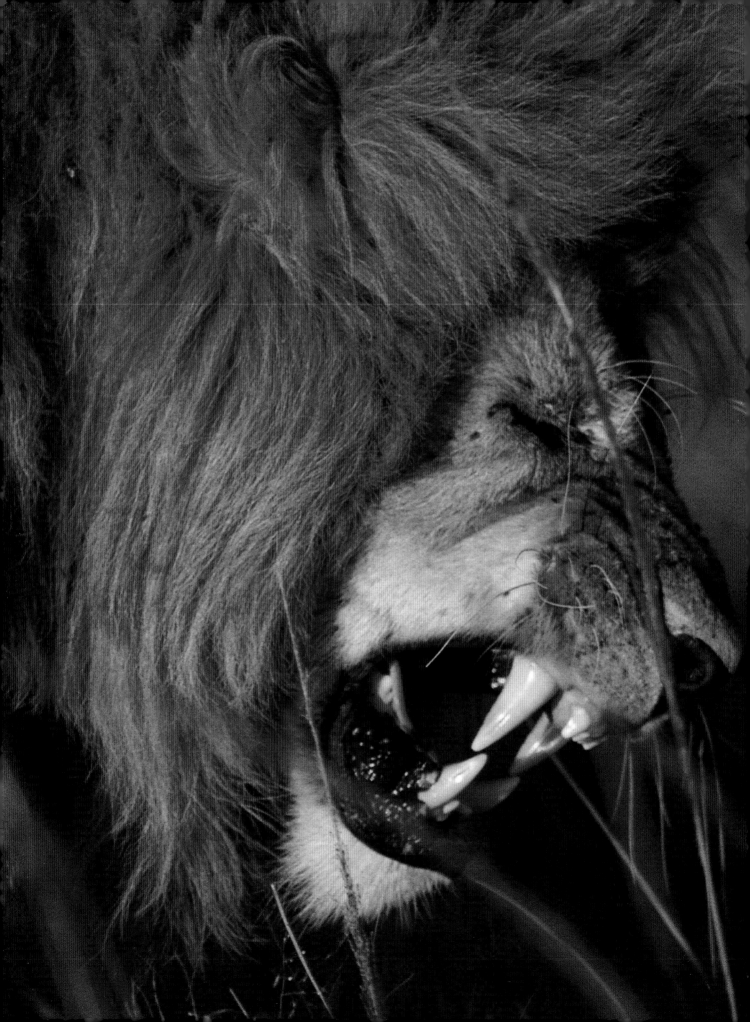

sharp thorny plants and dried-out grasses,
the dusty savannahs rustle and crackle
beneath the feet of the Beisa oryx.
The Grevy's zebra – characterised by the
narrow, dense stripes of its bi-coloured
coat – seeks out a few blades of tender
grass, impatiently waiting for the earth to
blossom forth again after the rains.
Cheetahs can be seen here; the flat, open
relief makes it easier for them to spot prey,
before approaching it by crawling forward
on their bellies. Hyena, whose monotonous
chant fills the African night, are not afraid
to steal their booty, unless they decide to

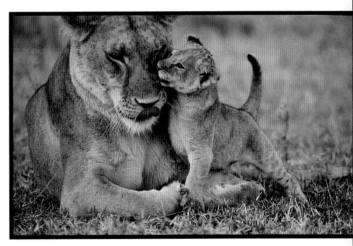

This snarling grin is typical of a
lion at the end of its brief
coupling. Mating takes place
every few minutes over a period
of several days – up to 200
times during the period the
female is receptive. You will not
have to wait long near a pair of
these big cats to photograph all
the stages of their mating
behaviour, using a long lens.
Here, the last rays of daylight
cast an amber glow on the lion's
mane and emphasise its dynamic
behaviour. The mischievous lion
cubs enjoy teasing the adults,
provoking a response to prove
their strength, and getting in
training for the future.
Sometimes they are just being
affectionate and their patient,
watchful mother leaves them to
get on with it. To witness such a
sight is a privilege, but you need
to know how to be discreet,
notably by using a long lens.

The white-throated bee-eater is one of the ten species of bee-eater to be found in the wooded regions of East Africa. Bees and wasps are only one part of its diet, however, for it will also eat other flying insects. A long lens is indispensable if you want to produce an interesting photo of this little bird with its shimmering plumage.

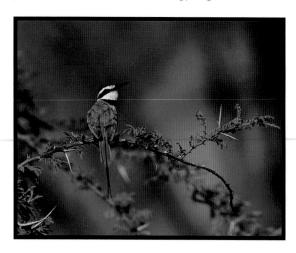

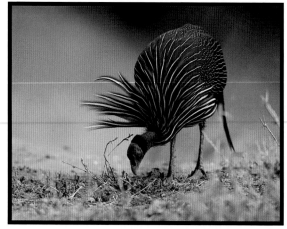

The grey-hooded kingfisher is a very common species in East Africa, so you often get the chance to photograph it. At home in wooded habitats, it uses a branch as a lookout to spot prey such as caterpillars, grasshoppers and beetles. A telephoto and quick reaction are essential to capture the moment as side light paints a motionless kingfisher, emphasising the dramatic red bill and brightly-coloured plumage.

hunt a careless gazelle themselves. In the deserted, sun-scorched plain parades a Somali ostrich, distinguished from the Masai ostrich by its greyish-blue legs and neck. A caracal crouching on the ground gives no hint of its presence, doubtless waiting to pounce on a passing mongoose or hare. Its patience exhausted, it abandons the spot and melts away into the bush. On the edge of the spindly scrub, a gerenuk standing up on its hind legs has found some fruit to nibble on a shrub. The elongation of its graceful neck has earned it the name which means 'giraffe antelope'.

On the other side of the river, the gently rolling relief of Buffalo Springs offers a view of Koitogor Hill, cutting into the sky on the horizon of Samburu at an altitude of around 1,200 metres. This and other hills rise up from the dry bush of the north, whilst marshes in the south are maintained by a network of seasonal streams

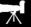

Unlike the more common helmeted guinea fowl, the vulturine guinea fowl does not have a caruncle on its head. The long blue and white feathers covering the breast seem almost to have been painted by an artist. Often moving around in groups, the vulturine guinea fowl feeds by scrabbling the soil with its feet to dislodge the seeds and insects which it favours. So as not to disturb the birds, the use of a telephoto is strongly recommended.

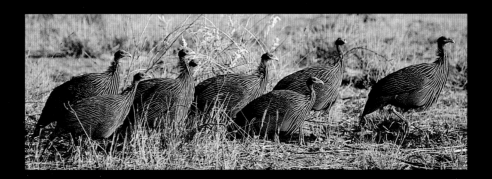

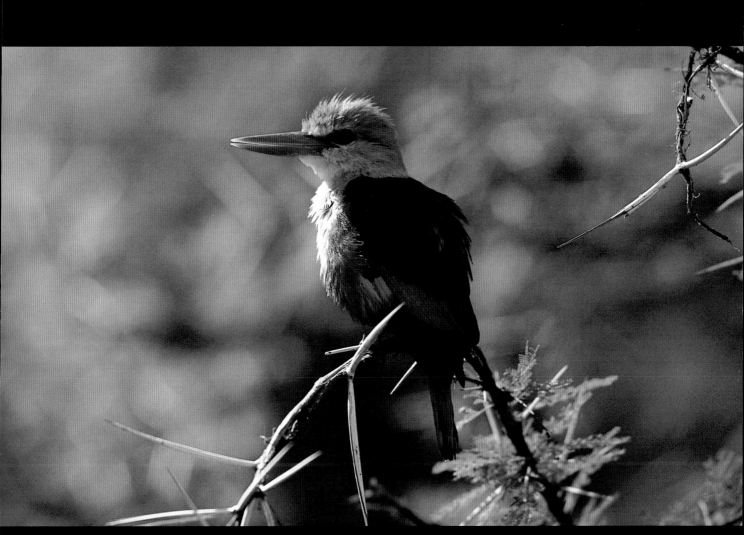

flowing at right-angles to the Ewaso-Ngiro, and underground springs including Samburu spring. Welling up within a cavity in the rocks, its clear water disappears, only to reappear a little further away as a muddy pond where all the animals nearby come to drink. In this way, these damp, verdant savannah landscapes create some surprising contrasts. Besides the presence of the large mammals – especially the irascible buffalo, which tolerates only the impudent presence of the cattle egrets – the proximity of these diverse habitats attracts an exceptional 450 species of birds.

Solitary and territorial, the leopard moves about mainly at dusk. It generally spends the day stretched out on a branch, where the disruptive markings on the coat make it hard to see. The rarity of this big cat, and its power and beauty, make it a legendary animal which all wildlife photographers hope to capture. Here the coat catches the light so well within the field of golden grasses. Make sure to keep your telephoto always at the ready.

Even rarer than the leopard, the caracal is a small feline cousin of the lynx. Distinct tufts on the pointed ears avoid any confusion with the other African carnivores. A skilled hunter, it is not afraid to attack birds. Fearful of humans, it is extremely hard to spot, and encounters never last more than a few fleeting moments. A long lens is essential for capturing the green eyes of this cat, eyeing the photographer within an environment where its plain-coloured coat blends into the dry scrub.

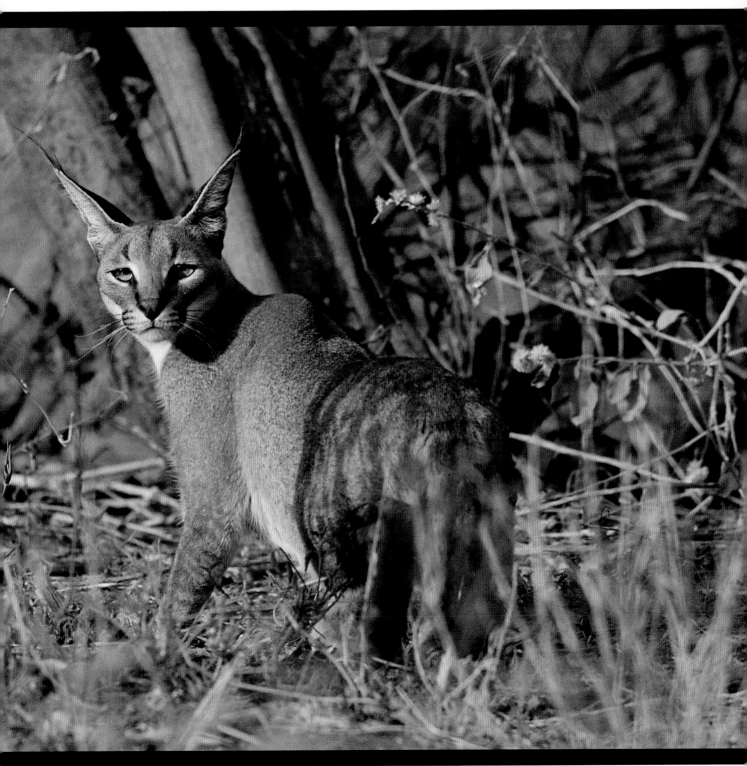

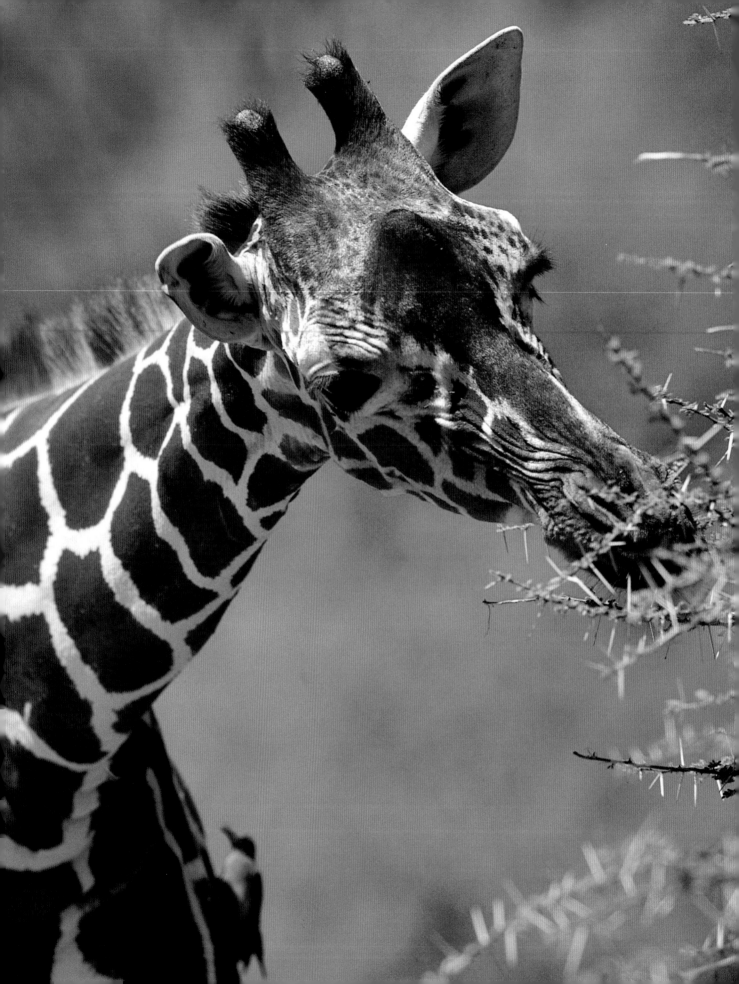

In Kenya, the greatest numbers of reticulated giraffe are found in Samburu and Buffalo Springs National Reserves. Eating mainly thorny acacia leaves, these giraffe have evolved a sturdy layer of keratin on their long, black tongues.

The especially viscous saliva allows it to chew and swallow this particularly prickly food safely. To photograph it like this in a magical morning light, while it daintily pulls off the leaves without hurting itself, a long lens is recommended.

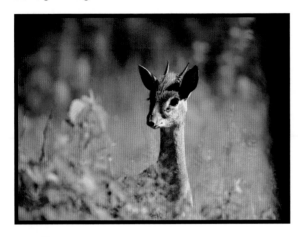

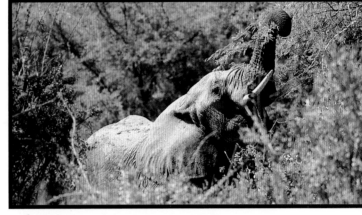

The dik-dik is a miniature antelope, scarcely bigger than a hare, which makes a choice meal for a serval, caracal, leopard, jackal, or even a tawny eagle. Dik-diks prefer dense thickets, where they can take cover at the slightest sign of danger. Taking a portrait of this graceful animal is quite tricky, not least because it is so small, and a telephoto is essential.

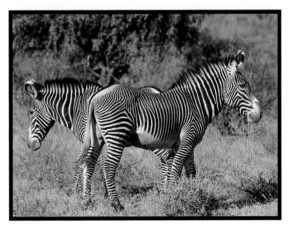

Numerous birds of prey criss-cross the clouds with their majestic flight. The martial eagle, bateleur eagle, fish eagle and chanting goshawk are amongst the most widespread. Aquatic birds too – including several varieties of herons and storks, and not forgetting the hammerkop and the Egyptian goose – colonise these ideal spots. Compared to other Kenyan Parks, the Samburu and Buffalo Springs National Reserves are relatively less frequented by tourists, making them all the more interesting, as they provide a tranquil opportunity to discover and share in the excitement of the bush.

The tenderest leaves often grow on the higher tree branches, but this does not deter an elephant, whose feeding behaviour makes an interesting photographic subject, using a long lens. The same goes for the Grevy's zebra, always on the alert and therefore difficult to get near.

21

Lake Nakuru

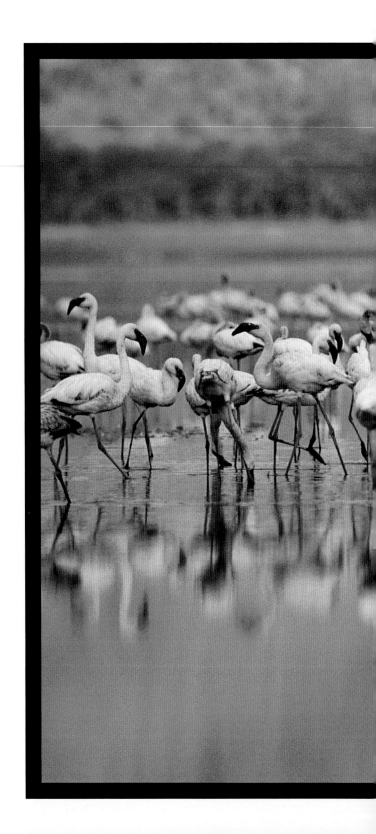

ake Nakuru National Park was set up in 1961, and originally included just the lake and its immediate environs. In 1974 the boundaries were extended to include the vast wooded savannah further south, and the Park now covers an area of around 200 square kilometres. At an altitude of 1,750 metres, the lake nestles in a trough fault between the verdant escarpments of Baboon Cliff to the west and Lion Hill to the east.

The Park comprises three major habitats. The lake itself attracts a large bird population, while the forests and savannahs shelter herbivores and some predators. Like most of the lakes in the Rift Valley, the soda (alkaline-saline) waters of Nakuru favour the development of abundant algal growth, which supports huge numbers of flamingos. The proliferation of these micro-organisms depends on the alkalinity of the lake's water, which relates to the amount of rainfall. In good years, the lake is covered with the pinkish plumage of millions of lesser flamingos and it is a gripping spectacle when they fly off in immense clouds into the bluish air.

Land to the south and west of the lake is occupied by a vast marsh, home to around 20 species of wading birds. Many of them come here from Siberia or Scandinavia to spend the winter months – when this habitat is invaded by sandpipers, plovers, storks, and avocets, not to

The colonies of flamingos are one of the finest sights in the African Rift Valley. They gather in hundreds of thousands on Lake Nakuru's soda waters where their food is plentiful. The delicate pink plumage blends well with the blue-green hues of the lake environment, which, coupled with the reflection of their bodies, makes for some magnificent pictures. Use a medium to long focal length lens, depending on how much of the setting you wish to include.

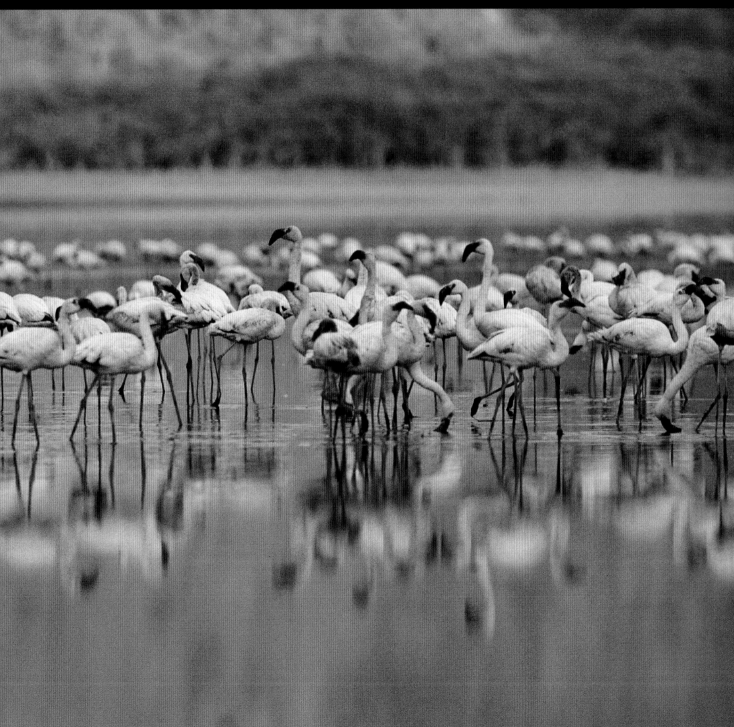

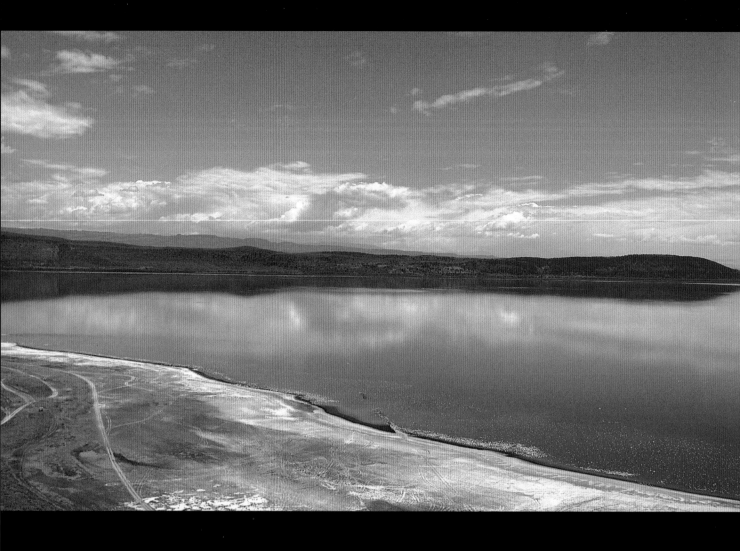

 Like Kenya's four other salt lakes, Nakuru lies below the volcanic reliefs. Minerals contained in the lava are washed down by the rains, and release large quantities of potassium, calcium and especially sodium. The lakes have no outflows and the heat causes considerable evaporation, concentrating the minerals which crystallise forming a salt crust outlining Lake Nakuru shores – evidence of a salinity that is significantly higher than that of the sea. A panoramic lens is ideal for photographing these contrasts of colour in the vast landscape. But without one, two adjacent shots taken with a wide angle will still let you recreate the whole setting.

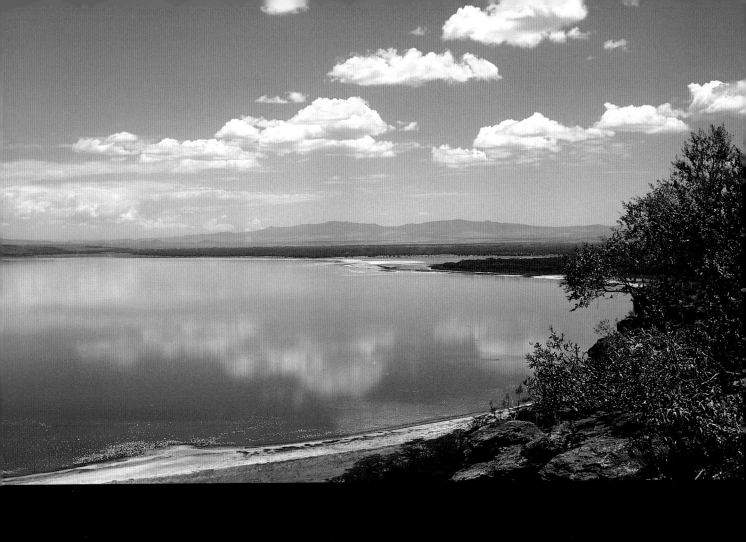
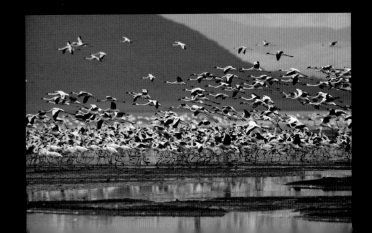

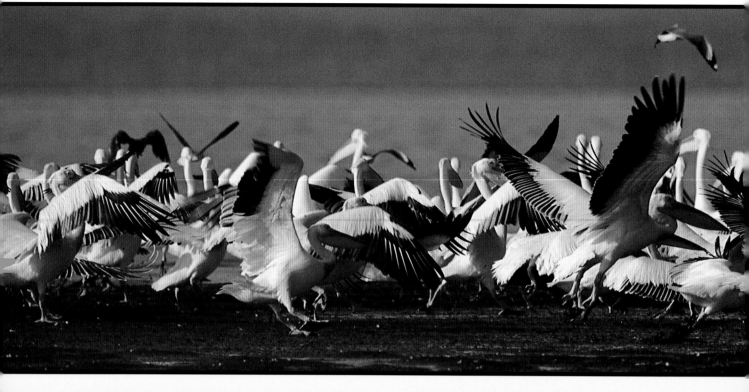

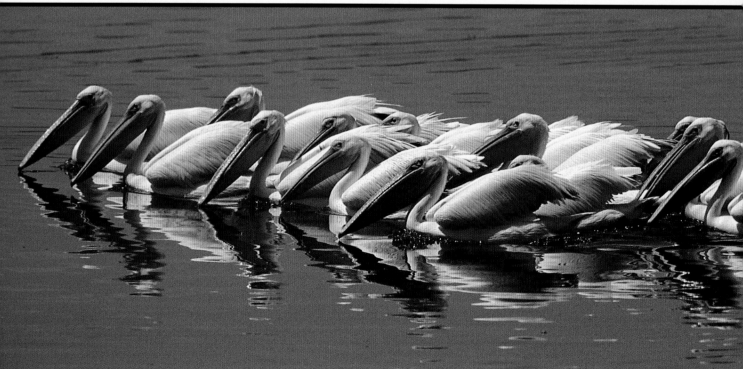

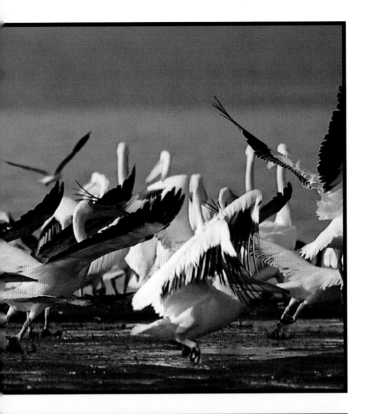

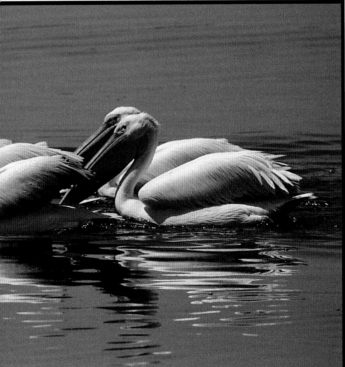

mention the sacred ibis. But the birdlife is most varied in the north and east of the lake, where fresh water running off the escarpment creates ponds and streamlets. The pygmy kingfisher in its shimmering orange and purple livery can often be seen perched on a slender twig, watching over the still waters not far from the purple heron, its curving neck emerging above the reeds. The squacco heron patrols in search of insects, which it will regurgitate for its chicks. No less discreet, the bittern with its cryptic plumage melts into the reed-beds. Going about their peaceful fishing, pelicans fill their crop with tilapia – this fish, imported into Lake Nakuru in the 1960s is the reason they stay here, just like the 3,000 great cormorants for whom this is one of the best feeding sites.

The Park's main forest zone lies to the south and southwest of the lake. Devoid of any tracks, some

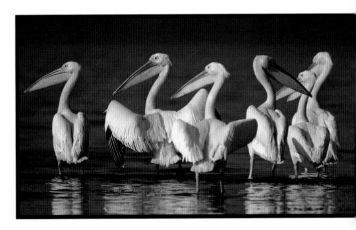

Prior to the introduction of tilapia into the waters of Nakuru, the pelicans were migrant visitors. Nowadays they stay, sure of finding large stocks of this fish – it has been estimated that up to 3,500 tonnes of tilapia are caught each year by the pelicans in Nakuru. This just goes to show how many pelicans there are, and how countless opportunities arise for photographing all the stages of their feeding behaviour. When the sun sinks towards the cliffs, the warm rays pick out the contrasts of their white and black plumage. Using a tripod to stabilise a telephoto lens helps to produce this type of picture.

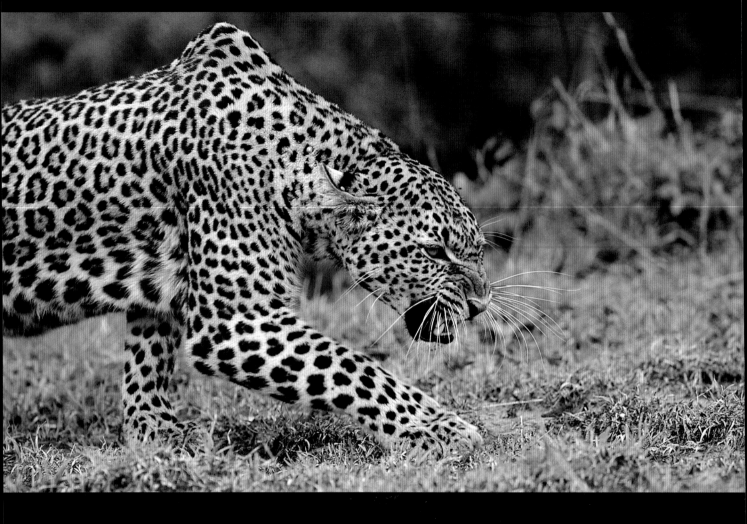

South of Nakuru is a superb
wooded savannah area where
leopards live. The territory of the
Park is small enough to increase
the chances of a face-to-face
encounter with this secretive
animal. Here, it took lightning
reactions and a telephoto to

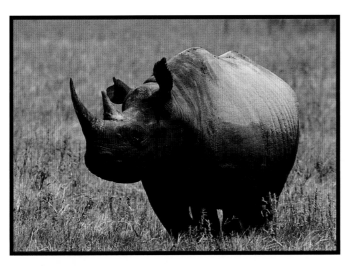

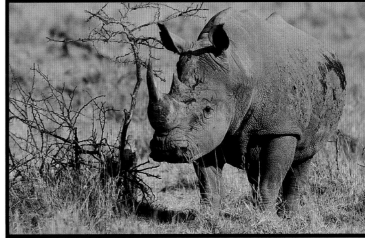

Rhinoceros are amongst the most endangered species because of their much sought after horns. These are an important ingredient in Chinese medicine and are also used for dagger handles in some mid-Eastern countries. The white rhinoceros had completely disappeared from Kenya until it was re-introduced in Nakuru in the early 1990s. The black rhinoceros has also been re-introduced. The white rhino has a broad mouth, quite different from the pointed, prehensile upper lip of the black rhino. Placid by nature – unless it feels threatened – a rhinoceros can occasionally be photographed using a medium-long lens.

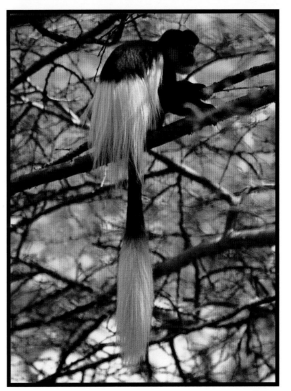

parts are completely inaccessible. The wild olive trees echo the cries and cheeping of the grey louries and barbets, as well as the parrots, their vivid colours illuminating the foliage. Honey badgers have their lair here, and sometimes a few sparse herds of buffalo stray here too. White rhinoceros, reintroduced here from South Africa during the 1990s by the South Kwazulu-Natal Nature Conservation Service, shelter under cover during the day not far from clearings where they can graze. The lake is ringed by a wooded fringe and, particularly near Lion Hill, by a forest of candelabra euphorbia that is the largest in eastern Africa. Their thick, fleshy branches contain a milky latex which is poisonous, so the majority of animals avoid these plants. However, a few mongoose and bushbuck, along with a number of rhinoceros –

Strictly tree-living, the superb black and white colobus monkey usually stays up in the forest canopy, making it almost impossible to observe. Even when it does come down to the lower branches, a telephoto is needed to capture the rare encounter.

which feed off the bark on the weird tree-like euphorbias – have settled here.

The extreme south of the Park is occupied by a vast wooded savannah. Waterbuck find food aplenty here. From the height of the leafy boughs, black and white colobus or guereza monkeys, in their silky greatcoats, scrutinise the surroundings. An agile leopard climbs the yellow fork of a fever-tree. Bee-eaters, mockingbirds and kingfishers perform a non-stop aerial ballet, while a giraffe disappears off into the evening gloom. Further east, the horizon opens out across a grassy plain, with the silhouettes of Bohor reedbuck and zebra. Along the rocky slopes slanting down towards the slate-grey lake, the presence of duiker may be revealed in the bushes. Black eagles and black kites nest in the crevices of the dark cliff-faces, which are also frequented by hyraxes and klipspringers. From atop these basalt cliffs you get the most fascinating view of the Park.

Nakuru is home to buffalo herds, which are always best photographed with a long lens. Between 100 to 170 centimetres at the withers, and weighing up to 900 kilograms, you can see why this animal needs to be respected – especially since it is irritable and unpredictable. It likes to stay close to the lakes and marshes, where it can wallow in the mud and drink its fill.

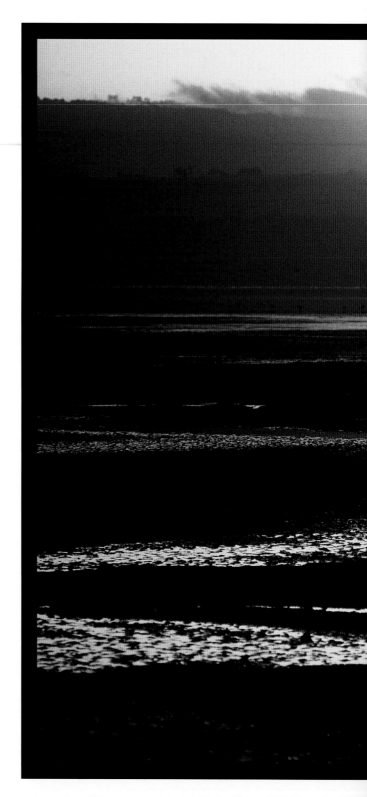

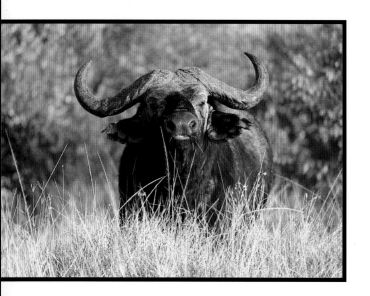

When the sun sinks onto the
ridges on the lake's horizon, its
rays still high in the sky contrast
markedly with the shadows to
create a graphic picture.
A medium length lens is ideal
for this type of image.

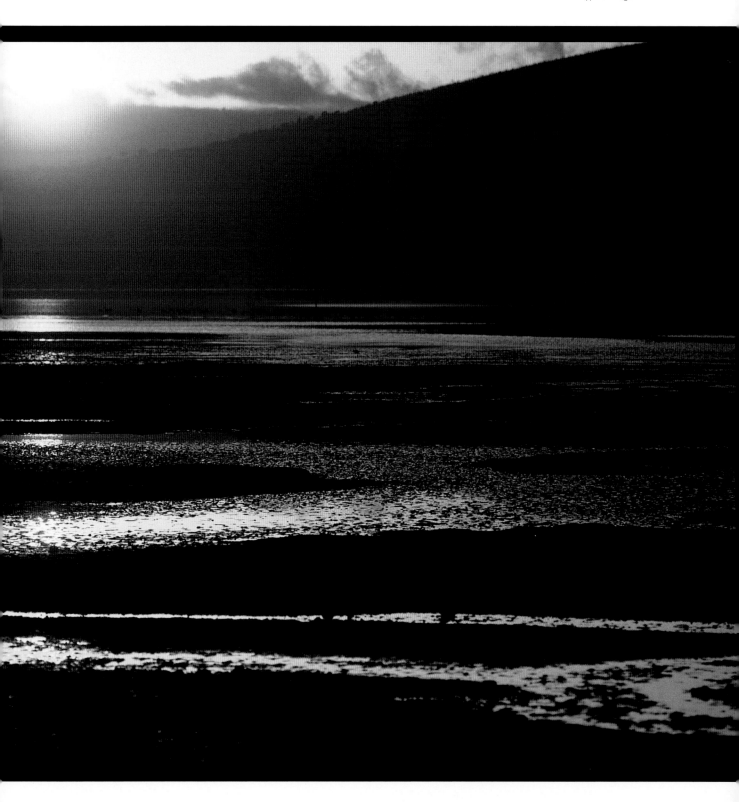

Along with Nakuru, Lake Bogoria is Kenya's leading site for flamingos. This is where they took refuge when the waters of Nakuru dried up completely in the mid-1990s. A hike takes you to the hills above the lake where a stunning overview shows how the flamingos are distributed. The dense concentrations close to the shores redraw the lake outlines. A medium length or wide angle lens will allow you to photograph this ever-changing scene, punctuated here and there by rising water.

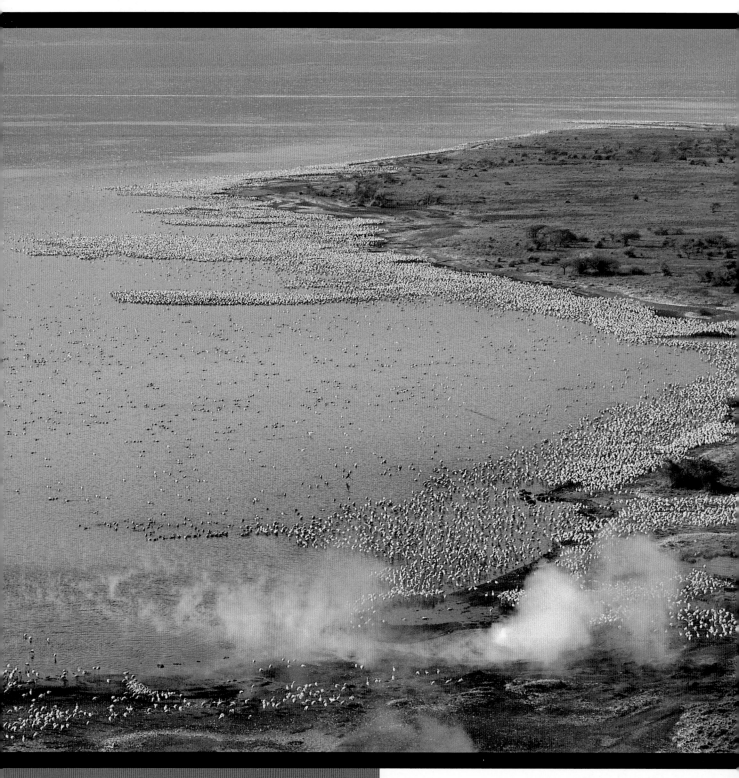

Lake Bogoria

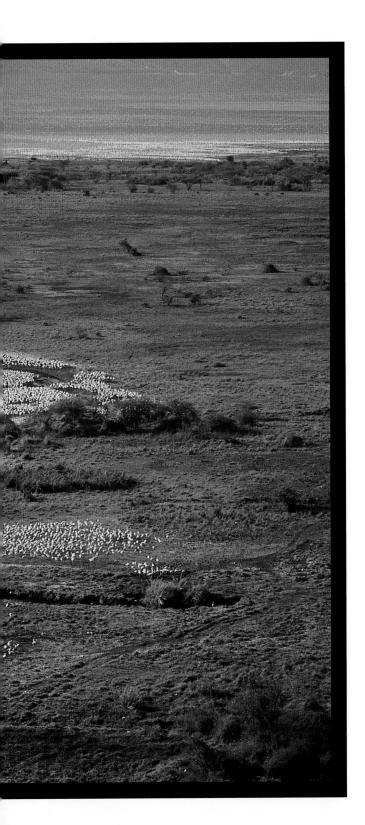

Located in a north-south corridor between Lakes Baringo and Nakuru, the Lake Bogoria National Reserve covers an area of 100 square kilometres, a third of which is taken up by the lake. It is one of the smallest reserves in Kenya, but is by far one of the most interesting ornithological sites in the continent. Oddly enough, the Reserve was set up in 1981 to protect not the birds, but the large herds of greater kudu based here. Fed by sulphurous hot springs, the lake is set deep within the lowest part of a vast rocky cirque, lending the spot an intriguing atmosphere. Like most of the lakes dotted along the Rift Valley, the waters of Bogoria are alkaline. With no outflow, the fierce sun causes evaporation, resulting in such a high salinity that no fish can live here. But, as in Nakuru, these conditions favour the growth of the tiny blue-green alga Spirulina that feed hundreds of thousands of flamingos. Their humming colonies gather, particularly at the south of the lake, braiding the emerald or sapphire-tinged waters with a long, pale pink ribbon. When the sun reaches its zenith, the lake in its dark lava setting glitters with myriad metallic reflections. This is certainly one of the most beautiful sights in the valley.

The bird population in Bogoria comprises nearly 400 species, including the thousands of migratory birds that come to winter here

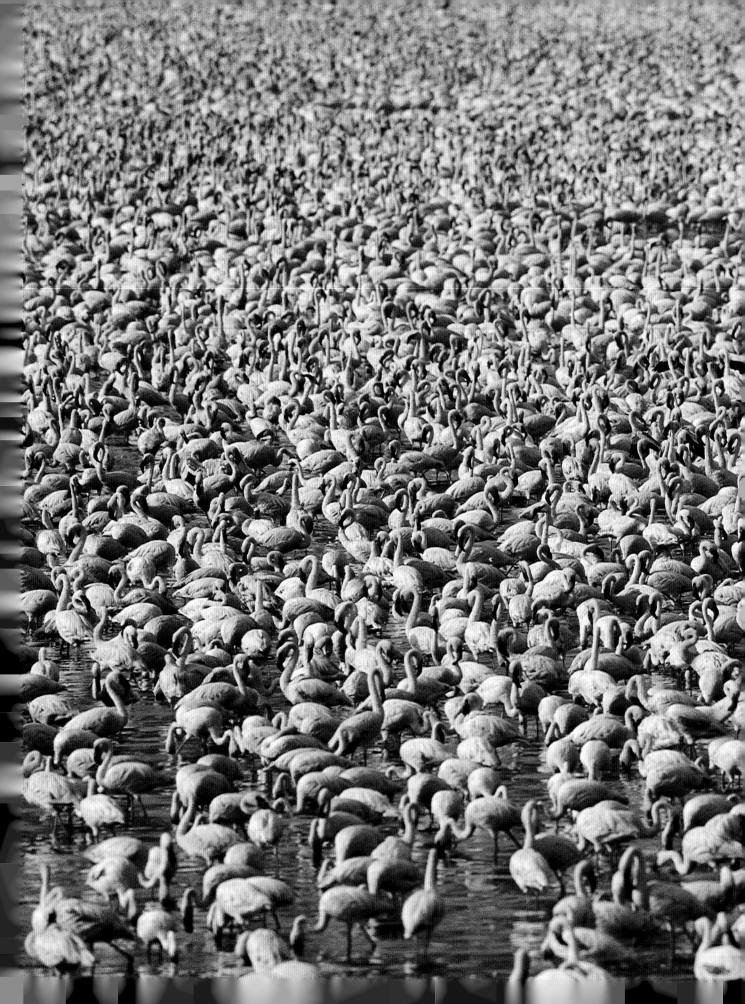

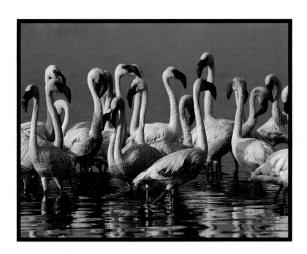

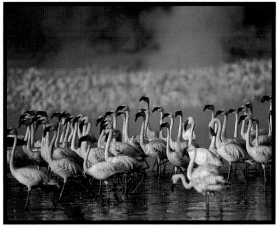

between October and March. To the north, the
Loboi marshes welcome numerous wading birds.
Amongst them, the black-headed heron builds its
nest in papyrus clumps. The African openbill
stork discreetly inhabits the occasional reed-beds,
along with teal, Eurasian widgeon, and the
enormous spur-winged goose – not forgetting all
the different varieties of stork and ibis. In the
surrounding area, various eagles, harriers and
falcons nest and feed not only on fish and
shellfish, but also on birds. Of the smaller birds,
six species of bee-eater are found in the
neighbouring habitats. To the east, the horizon is
limited by Siracho Cliff, its silhouette reflected
in the lake. Closer inshore, where the Laikipia
Escarpment slopes plummet towards the water, is
a route favoured by greater kudu as they hurry
down at dusk to drink at the freshwater springs.

Intense geothermal activity affects the southwest
of the lake, manifested by the expulsion of

In the best years, around two
million flamingos colonise the rich
Bogoria waters. The smaller lesser
flamingos are a hundred times
more numerous than the greater
flamingo. But with different diets,
they do not compete with each
other. The lesser flamingo filter
feeds on micro-organisms such as
algae, while the greater flamingo
filter feeds on crustaceans and
molluscs and some algae in the
deeper waters. Birds in such high
concentrations offer unlimited
opportunities for varying the
composition of photographs.
Use a wide angle to embrace
the seething multitude, or a long
lens for closer shots of just a
few individuals.

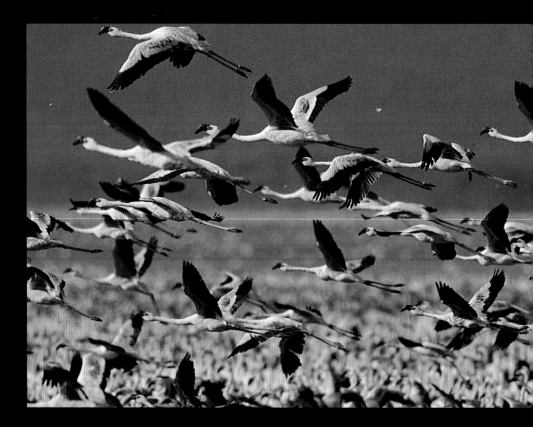

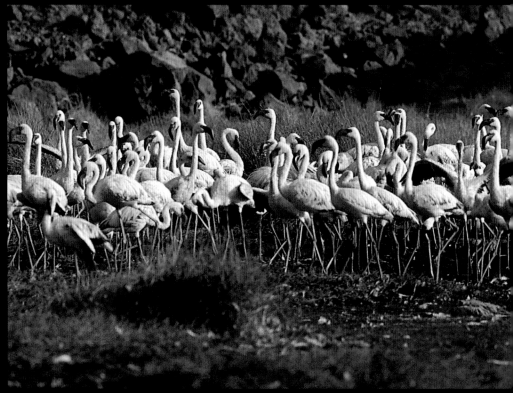

As flamingos take off they present a magnificent spectacle. When one decides to leave it is immediately followed by hundreds of others. They may alight again nearby, or they may climb high into the sky, their immense flightlines piercing the clouds with a myriad of pink arrows. On the ground or in flight, in front of the shadow of the blue cliffs or against the brilliant green of the damp vegetation, the light makes each bird stand out precisely. A medium length lens is well suited to this type of photo, but the spectacle is so varied that other lenses should not be ruled out.

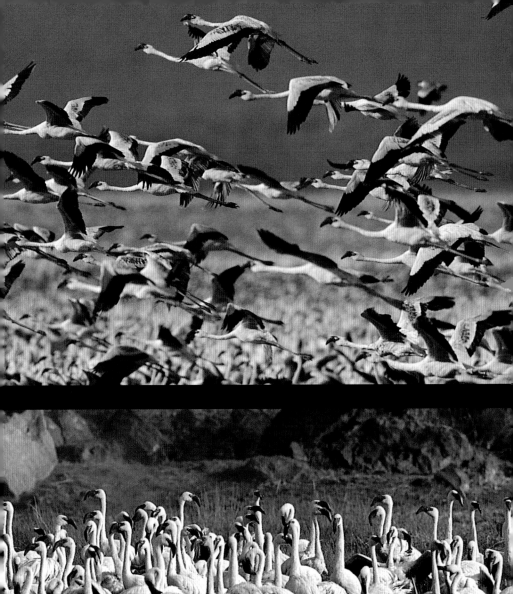
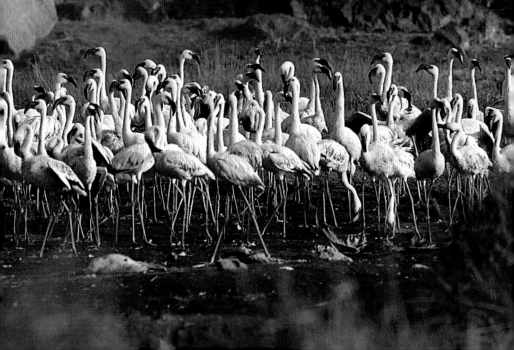

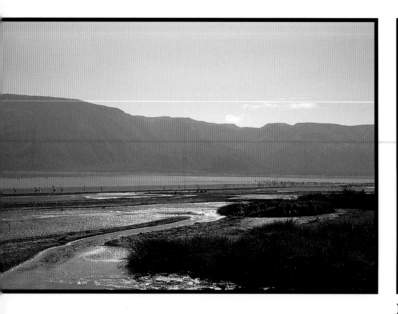

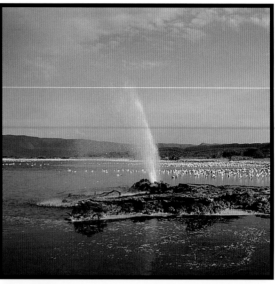

powerful jets of scalding steam from the basalt concretions. These jets, which can spurt up to six metres into the air, reach a temperature of 100° Celsius and give off an unpleasant sulphurous odour. Although the soil around them appears solid, it is no more than a fragile crust covering a magma of hot, slippery mud, where it is dangerous to venture. Behind the clouds of droplets outlines of a few flamingos are visible, otherwise animals are rare in this inhospitable environment. A few Thomson's gazelles and klipspringers may appear. The agility of the latter really comes into its own here, earning them the nickname of 'rock-leaping antelopes'. Lake Bogoria and the adjoining areas offer the curious visitor numerous attractions and make it a favourite stop on a safari.

Lake Bogoria's geothermal phenomena are evidence of the Rift Valley's continuing volcanic activity. Fed by sulphurous hot springs, the lake is the only one in the Rift Valley to have geysers. The closeness of a teeming mass of flamingos swarming behind curtains of hot steam may be an opportunity for some superb pictures. In any case, the geysers themselves are a spectacle worth photographing, whether you shoot them using a wide angle to give an impression of their scale within the rocky landscape, or use a medium length lens to frame the whole plume, catching the glittering droplets in a lovely morning light.

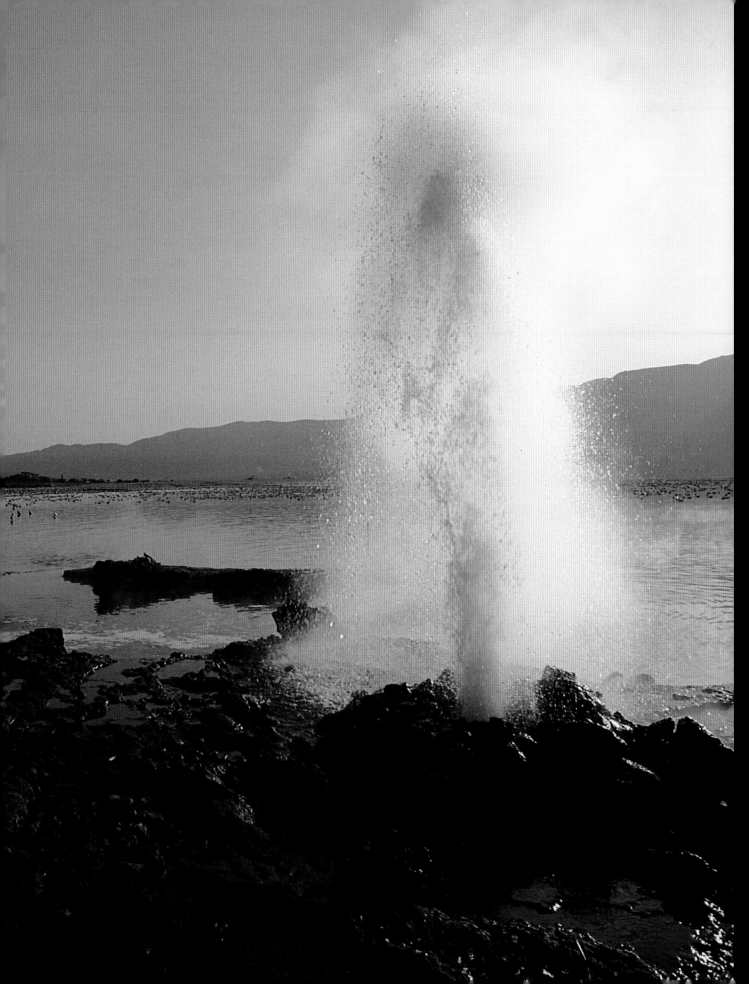

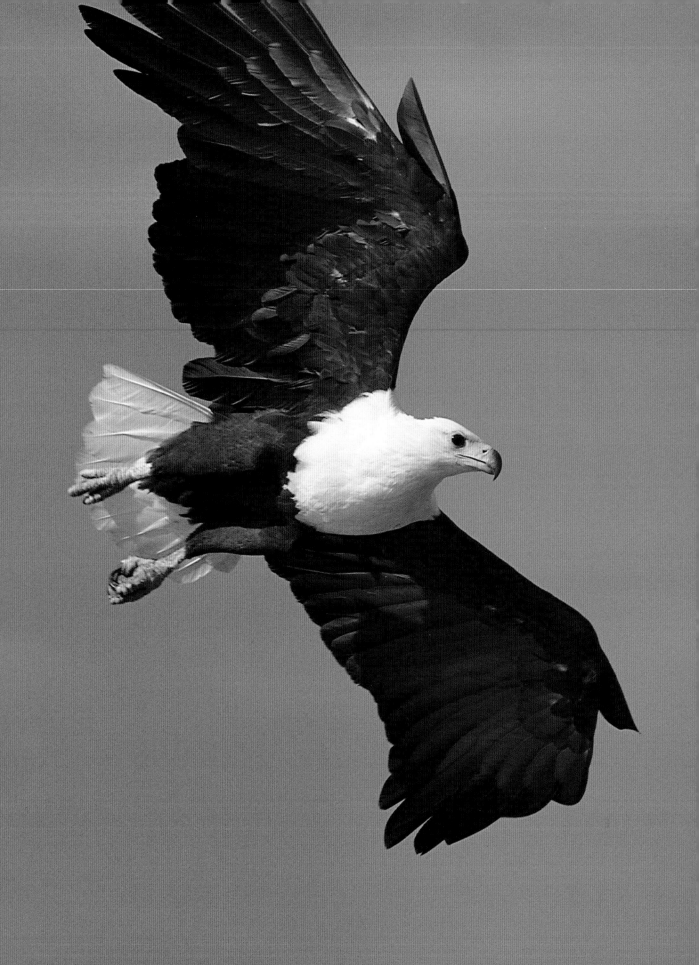

Lake Baringo

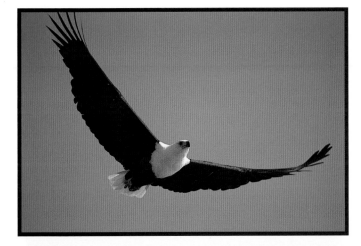

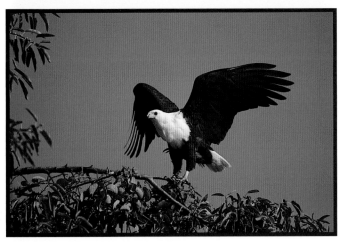

The African fish eagle is one of Lake Baringo's major attractions, with several tens of pairs nesting here. As its name indicates, it eats fish, but also consumes aquatic birds, especially lesser flamingos, whose colonies it often attacks. Easily identifiable by the colour of its plumage, the fish eagle has a wingspan of almost two metres. It is most active in the morning and you will need to hire a skipper with his boat to get close. Despite its good size, you will still need a long lens, often used at arm's length, to capture it in flight. Such photos are hard to achieve – but it is still worth trying.

Until the authorities recently decided to turn it into a conservation area, Lake Baringo did not have any official status, and only the local people's profound respect for the site gave it some degree of tacit protection. The area of the lake varies from 130 – 170 square kilometres depending on its level, which in turn is determined by the amount of rainfall. This freshwater lake is laden with sediments and the silt washed down by violent storms regularly reduces its depth to less than 30 metres. It is one of the least alkaline lakes in the Rift Valley and does not attract flamingos because the Spirulina algae, on which they feed, cannot flourish here. The Baringo crocodiles are generally fairly small, but many frequent the lake shores. There are few mammals left, since their numbers were dramatically reduced by an epizootic in the early twentieth century. All the same, you may spot a solitary dik-dik, as well as the occasional herd of Grant's gazelles scattered through the under-growth, and doubtless a few common waterbucks. The nocturnal aardvark, an odd sort of animal, and a distant cousin to the anteater, has also been seen.

The site's main interest lies in its fantastic birdlife – 458 species congregating around the lake, which

is dotted with several islands of volcanic origin. One of these, Gibraltar, is home to the biggest colony of goliath herons in East Africa. Though the north of the lake offers a marvellous panoramic view of its waters, tinted bronze by the vagaries of the sunshine, the largest bird population is found on the western and southern shores. Occasional rivers lead to marshes that link to the mouth of the Molo river, which is colonised by hippos. Amidst the reeds cormorants dry their wings, while jacanas move with agility on floating water-lily leaves. The yellow-billed storks sit and wait for the pelicans to drive the fish towards the shore before they go fishing. With the brown water half-way up their legs, spoonbills and egrets too search for their food, some distance from the pirouetting pied kingfishers. The lake and its shores also offer a fine concentration of the impressive African fish eagle, the undisputed monarch of the sky. Several thousand chestnut

The sun rising over Bogoria sets the horizon aflame, as the night slowly leaves the sleepy landscape, giving way to the sunlight that will soon be warming the land. In this solitary spot the atmosphere is serene; only a few songbirds break the silence of the dawn. The light is still too poor to allow a fast shutter speed, so to ensure a sharp image it is strongly recommended, even with a wide angle, to mount the camera on a tripod.

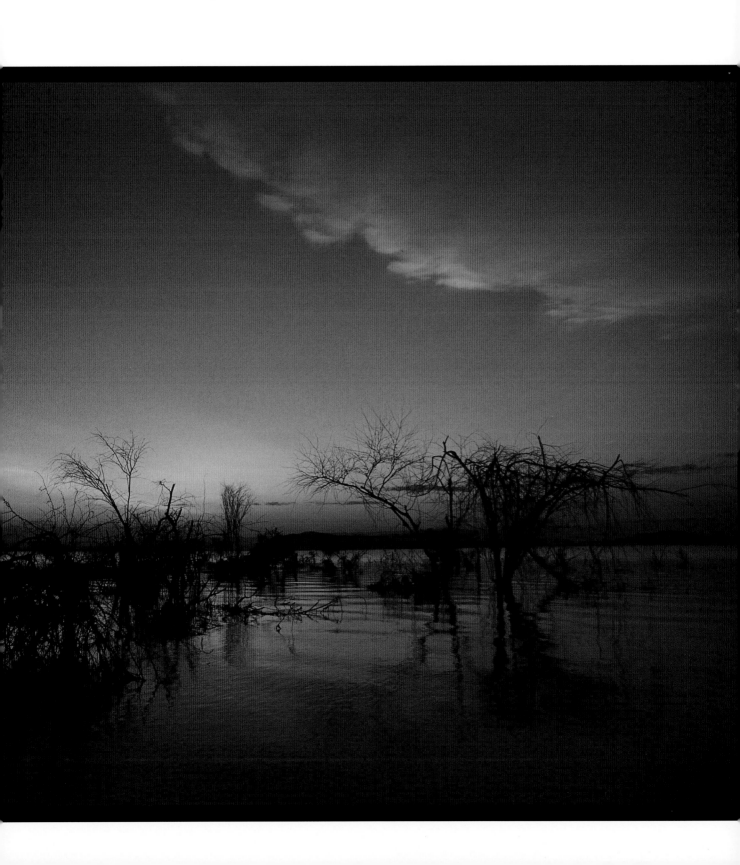

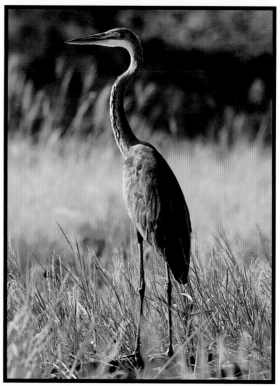

Baringo is home to numerous wading birds, in particular several varieties of heron, including the grey heron and the largest of them all, the goliath heron. The great white egret is related to them, and flies with its head tucked back onto its shoulders. Very common in Baringo, the hammerkop often falls victim to the fish eagle that steals its prey. Fairly bold, the malachite kingfisher never perches far from the water, where it dives in search of food. To photograph all these birds a long lens is essential, as it is not always easy to get close to them. In flight, on the ground, bathed in warm light or a silvery backlight – there are many possibilities for creating pictures.

weavers breed here; hanging from the branches of isolated acacias, their skilfully-woven nests swing gently in the breeze. To the west, flanked by abrupt cliffs topped with bushes and fig trees, the black eagle and the Eurasian kestrel find refuge. Sheltered in the deep gorges cut into the escarpment, the silvery-cheeked hornbill may make a stopover in the exuberant vegetation generated by the captured rainwater. From October to March all these residents share their territory with the migratory birds coming from the colder regions of Europe and Asia. Lake Baringo is a Mecca for bird-watching, and is visited all year round by many ornithologists as well as naturalists passionate about birds.

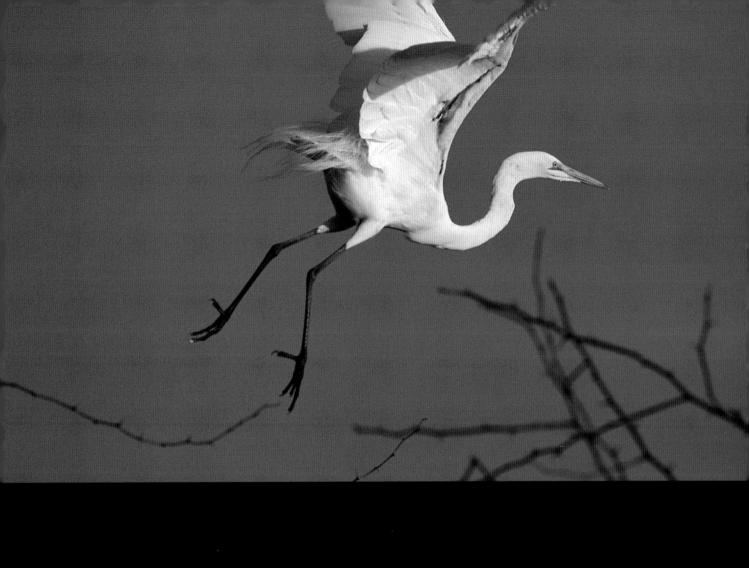
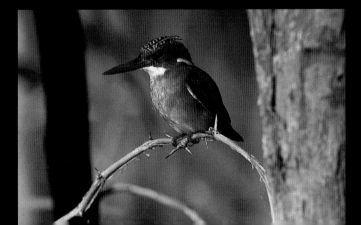

At the end of the rainy season, heavy clouds darken the long plains of the Masai Mara, all ready to empty their deluge of water onto the still-damp earth. When the sun breaks through the mantle of clouds, its silvery backlit rays seem to be part of some divine manifestation. A wide angle lens makes it possible to encompass the dramatic dark clouds modelled by the unearthly light.

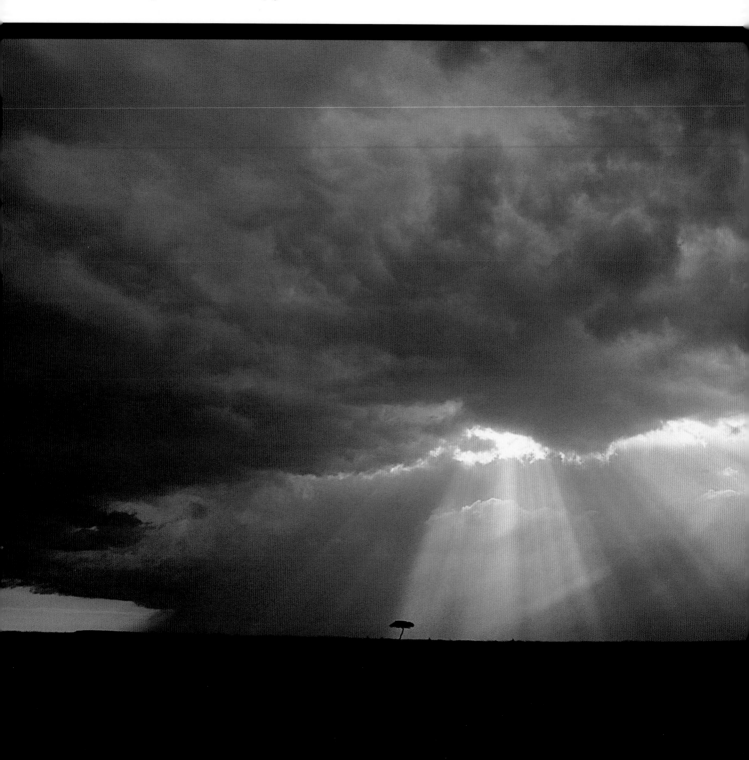

Masai Mara

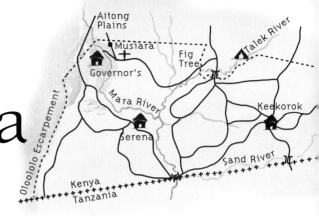

The Masai Mara National Reserve is a wildlife paradise and this, together with the stark beauty of the scenery, makes it one of the top safari destinations in the whole of Africa. Contiguous with Tanzania's Serengeti National Park to the south, with which it shares a common ecosystem, the Masai Mara occupies an area of 1,800 square kilometres. The western third of the Reserve is an area known as the Mara Triangle which covers 510 square kilometres. Within the rest of this vast territory there are some Maasai villages and herdsmen are allowed to graze their flocks. Located on a plateau at an altitude of between 1,500 and 2,000 metres, the rolling relief of the Masai Mara is bounded to the east by the inhospitable Loita and Ngama hills, to the west by the Esoit Oloololo escarpment, and to the north by the Aitong Hills. It has the highest rainfall of the whole Masai Mara-Serengeti ecosystem, ensuring a constant source of food for the animals.

A variety of habitats: marshes, placid or turbulent rivers, grassy plains — sun-bleached or verdant — depending on the season, shrubby or wooded, craggy or eroded hills, all provide a haven for the larger African fauna.

47

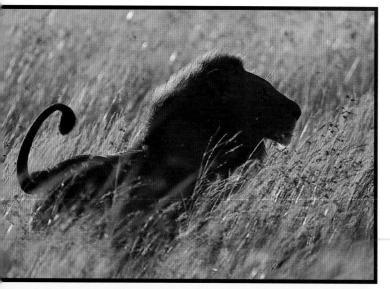

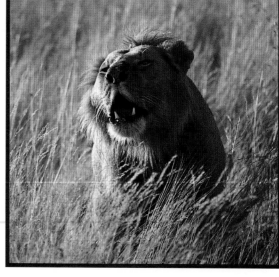

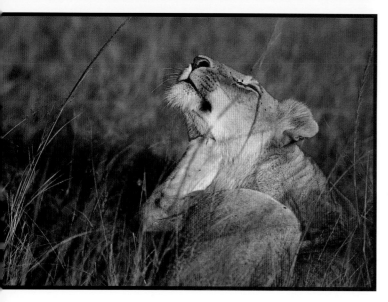

The Mara River marks the natural eastern boundary of the Mara Triangle, flowing in a north-south direction through the very heart of the savannah, while its tributary the Talek flows at right-angles across the undulating steppes of Burrungat. The water level in these two rivers varies depending on the rainfall, but their unequal flows never dry up completely, and support rich gallery forests with large wildlife populations. To the north, in the blue shadow of the Siria Cliffs, stretch the Musiara Swamps.

Immediately adjacent to the meanders of the Mara, this marshy region sees a remarkable congregation of bird populations, including many of the 500 species noted in the Masai Mara. It is not unusual to see the crowned crane with its head-dress of golden feathers, as well as the hammerkop – scrabbling with its feet in the mud to unearth a fish or small amphibian – and the ground hornbill walking through the yellow grass in search of a reptile. Less choosy in terms of food, the marabou stork is also well represented here. This big, bald stork is ready to gobble up

There is such a concentration of lions in Masai Mara, it is rare not to see one, especially when migrating wildebeest invade the plains. Having followed the antelope column from Tanzania, the nomadic lions join the resident lions. If you spend several hours in the company of these great cats, you will be sure to see various kinds of behaviour, but they are most active in the first and last hours of the day. As the sun's light is also finest at these times all the conditions combine to produce magnificent pictures, using a medium length or long lens depending on the framing desired. The beauty of the animal, the colour of its coat, the graphic quality of its silhouette, its playful nature, all contribute to the success of the photos.

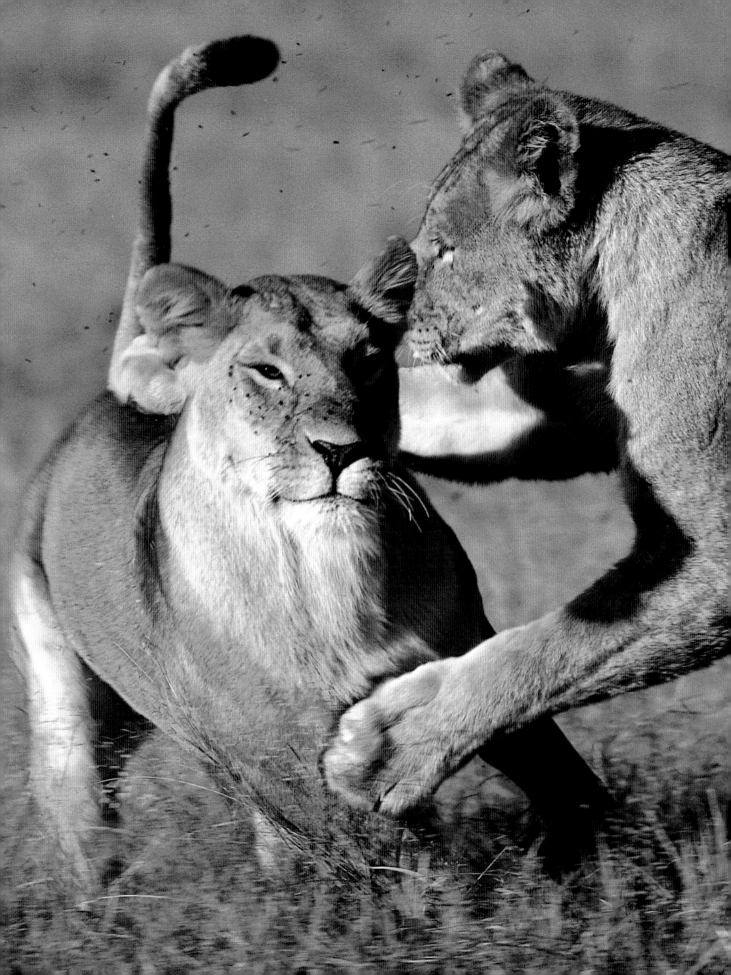

The cheetah is the fastest land animal – reaching a top speed of 110 kilometres an hour. But it lacks endurance, so cannot maintain full speed for long. Slender, sleek, standing tall on its large paws, it is a veritable sprinter. Photographing it running is a rarely-achieved pleasure, involving the use of the motor drive, most often at arm's length, while still maintaining the framing. Even with a good telephoto with a faultless autofocus, the results are unpredictable. But what a memory!

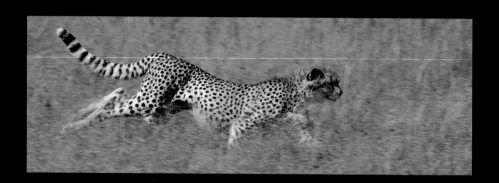

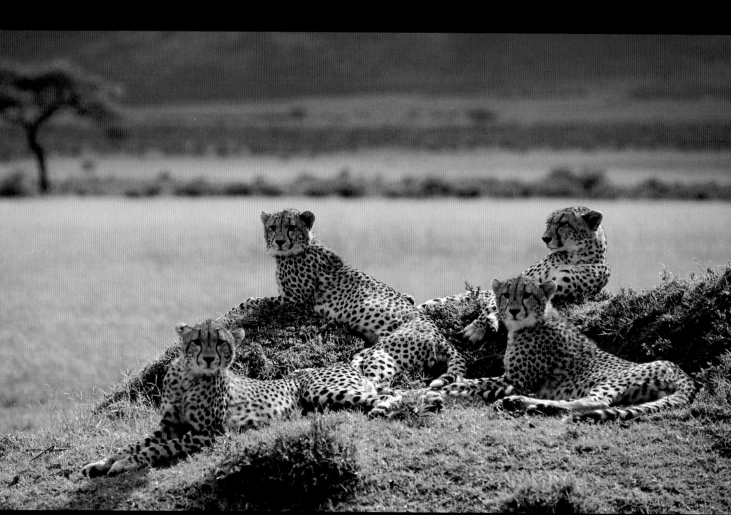

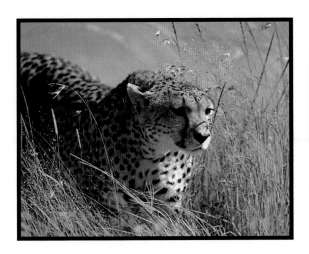

any animal matter, from the tiniest insect to elephant meat. Along the rivers, the hippos find somewhere to bask, passing whole days in the sediment-laden water, under the cold gaze of the crocodiles languishing on the sandy banks. Strident cries of baboons often rip through the tranquil atmosphere; amid the gleaming greenery adult elephants enjoy a treat of fresh shoots, imitated by the younger ones. The beady eye of the Defassa waterbuck pierces the vegetation to spy the shy duiker and the rare sitatunga, although the latter really prefers waterlogged, unstable ground. Giraffes are also attracted by the abundance of food, and can frequently be spotted stretching their long necks to gather tender leaves from the highest branches of the acacias. Many birds also inhabit the wooded strip running along the tortuous river courses, and the predatory long-crested eagle will attack monkeys in the canopy.

Cheetahs are easiest to photograph at rest. Groups often consist of a female and her young, as here. Now as big as their mother, they will soon be leaving her to occupy a new territory. In the meantime the female continues hunting to feed them, and watches their games benevolently. The elegance of the big cat, the luminosity of the light on its fawn, woolly coat marked with dark rosettes, the dark tear marks running down from its eyes, its haughty bearing – all are features that lend it a definite majesty. The symmetrical poses, together with its behaviour, make the cheetah irresistibly photogenic. Medium length and long lenses are recommended for these pictures.

For the most part, the Masai Mara consists of vast, undulating plains shaded here and there by acacia and sausage trees. These are the realm of the large herbivores and their predators. The great wildebeest migration takes place here in the western half of the Reserve each year. Following an unchanging ritual, these antelopes leave the Serengeti around February, just after giving birth to their young, and come to the Masai Mara in search of verdant pastures. Towards the months of July and August, almost two million of them flock onto the nourishing plains of southern Kenya. Yet 10 percent of the herd will die during this spectacular migration. Crossing

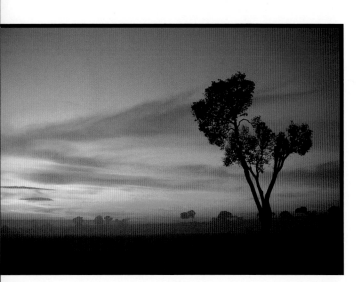

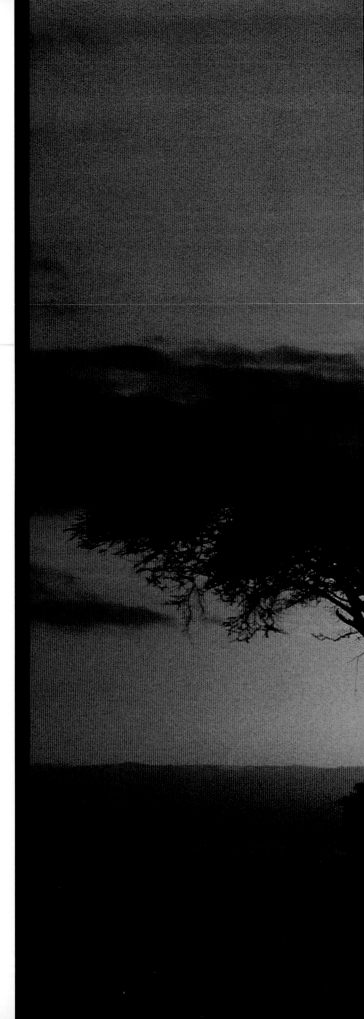

Every day, the sunrise is a marvel as it bathes the land in a fresh light, revealing new, harmonious colour combinations. Wide angle and medium length lenses will make it possible to photograph the depth of the sky, the silhouette of the trees still wreathed in the night. An awakening savannah can present predictable images, but also irrepressible ones, so bewitching are the landscapes and atmospheres created by the African dawn light.

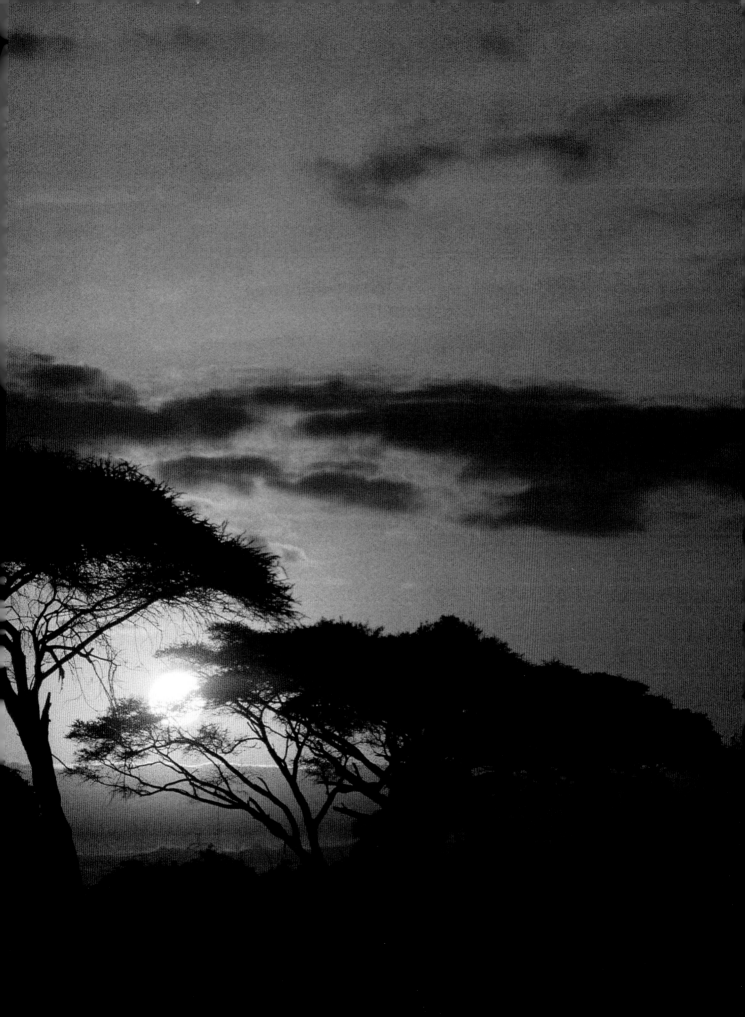

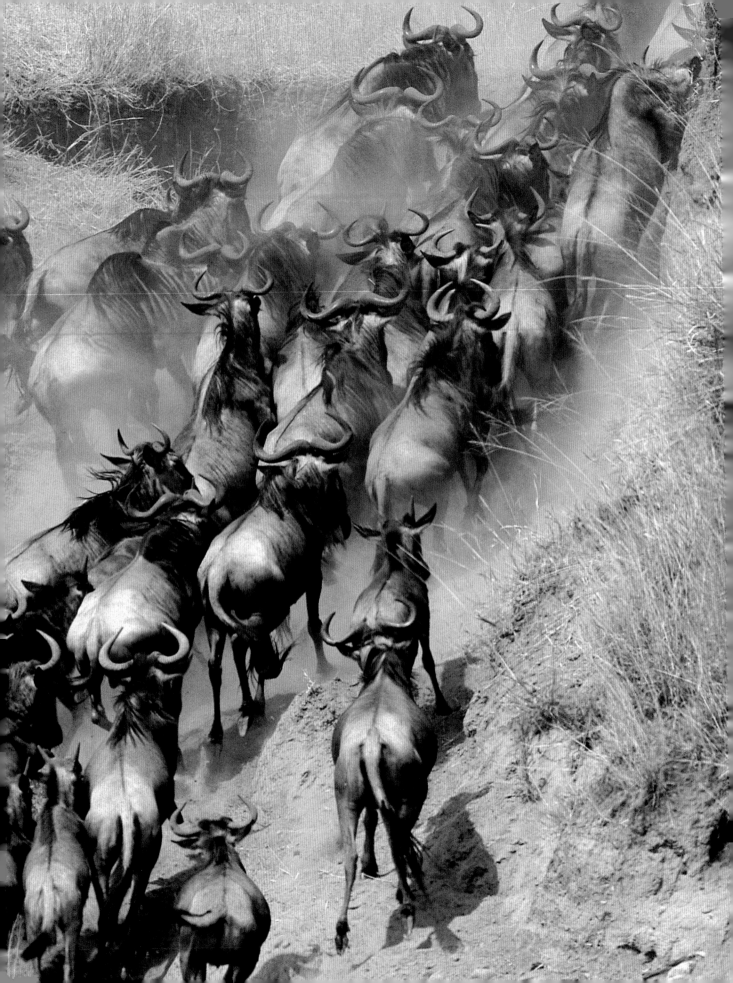

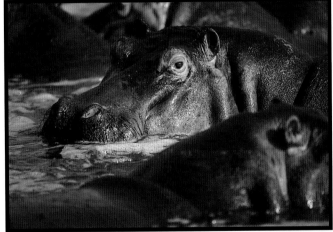

the Talek and Mara rivers is dangerous, and thousands of wildebeest throwing themselves off the steep banks creates a scene of complete pandemonium. Amongst those that perish, some drown, others break bones, some are trampled by their fellows and others are devoured by the crocodiles lying in wait. Come October, like a tidal wave, the migrations ebb as the herds return to the Tanzanian savannahs. Burchell's zebra, Grant's and Thomson's gazelles are the species most commonly associated with the wildebeest, because they favour the same feeding grounds. It is sometimes hard to distinguish between the herbivores when the russet shadows of the gigantic mixed herds colour the savannah. Their presence is bait for the big cats and all kinds of scavengers. But for the moment, the cheetah's fluid sprint across the long plain of cropped grass leaves not the slightest chance for the young jackal it has decided to attack. The leopard,

The wildebeest migration between Tanzania and Kenya is probably the largest movement of terrestrial animals. River crossings provide a real feast for the Nile crocodiles, which station themselves in large numbers at the crossing-places where the migrating antelopes often have trouble clambering up the steep, slippery banks. The hippos spend the day immersed in the muddy water to protect themselves from the burning sun, adjacent to flatter banks from which they can easily emerge to reach their night-time grazing grounds. To photograph the countless scenes that unfold around the river, you will need all your lenses.

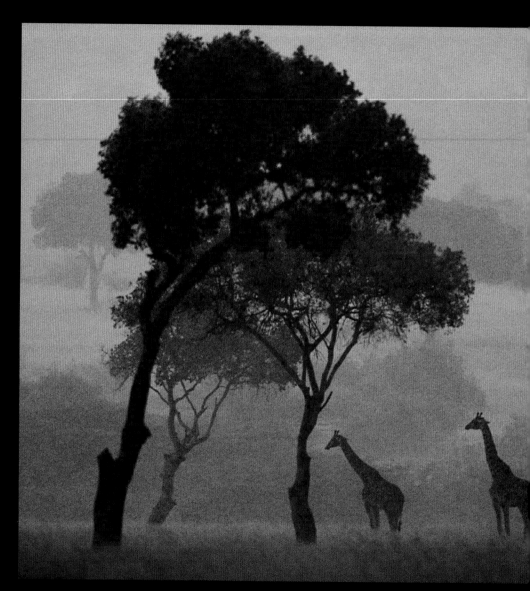

Bad weather – like the driving
rain here – can be the
photographer's unwitting ally.
Even when the sun goes in, you
need to learn to look around,
taking in the details of your
surroundings, searching them
to uncover a new emotion.
Do not be afraid to work in
the rain, providing you protect
your camera. This ghostly
silhouette of four giraffes,
standing out from the subdued
atmospheric landscape, is both
sensitive and original.

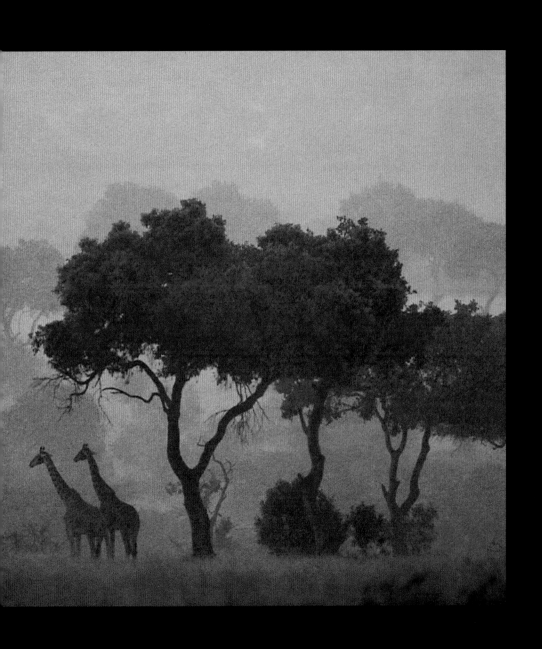

stretched out on a horizontal branch, prefers to wait for dusk to creep up on its prey – a hartebeest, a warthog, or even a baboon or vervet monkey – and then stifle it with a fatal bite. It is no accident that the Masai Mara is renowned for its concentration of big cats and it claims the highest density of lions in the country. Living in family groups, they blend in with the dry grasses of the amber savannahs, where the intrepid females pick out the most vulnerable or weakest individuals from a herd of buffalo. Thieving and bold,

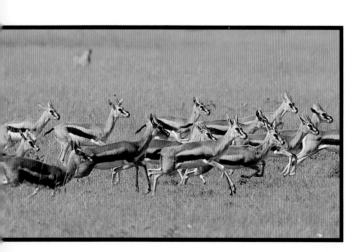

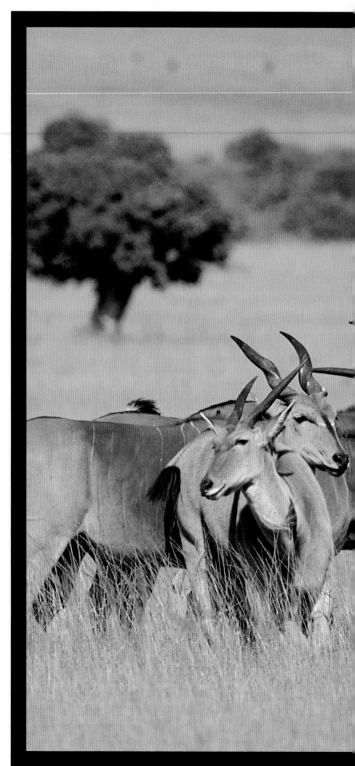

Herds of Thomson's gazelles often intermingle with Grant's gazelles, so they are commonly confused. But although they both have the same dark band on their flanks, the Thomson's gazelles are smaller and their coat redder in colour. They like the plains of lush grass, which they share with zebra and wildebeest. A group photo like this needs a medium length lens.

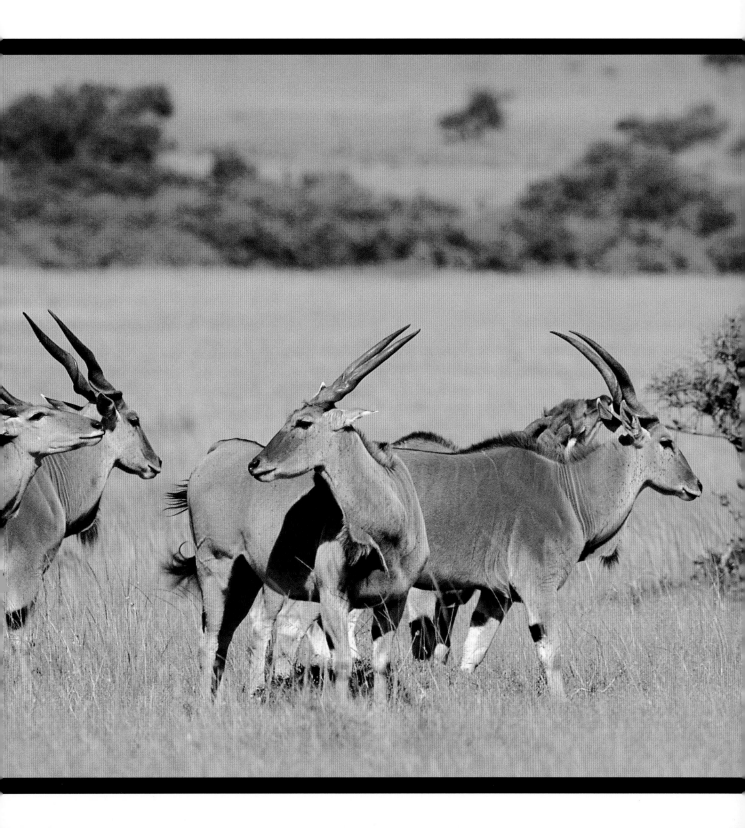

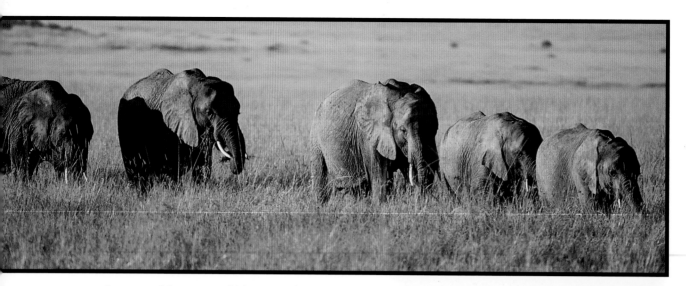

the spotted hyenas would be more than capable of fighting them for their enormous victim. The vultures are already circling high in the sky: once the hunters' feast is over, they move in to finish cleaning up the carcass. These scavengers, with an enormous wingspan, are amongst the fifty or so species of raptors noted in the region. One of these, the powerful martial eagle, would not think twice about swooping down on a young bat-eared fox, and flying off with the prey to eat it elsewhere, although the twilight habits of this small fox with large ears make it a secretive animal and help to avoid predation.

Of all the fauna in the Masai Mara, the African wild dog is indisputably the rarest and the most endangered. In fact, the National Reserve is one of its last refuges in East Africa, where its numbers are dangerously low. This wild dog was at first the victim of its own bad reputation, due to the ignorance of man, who almost succeeded in eradicating it. Then it was almost wiped out by canine distemper, transmitted by domestic dogs belonging to the Maasai. In the southeast, the great central plains of the Masai Mara lead

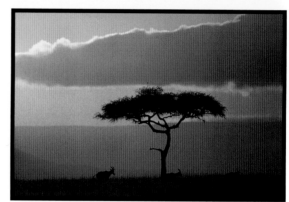

A medium length lens has made it possible to photograph the elephants' slow advance as they return to their feeding-grounds in the warm morning light. This is the time when the sun on the Masai Mara horizon is setting aflame the last clouds of the night and lifting its veil of light over the vegetation and animals.

Here, the hyenas' curiosity is alerted – they have been hunting during the night and do not under any circumstances want to share the left-overs of their feast. The backlit shot with a long lens makes it possible to achieve a tight crop, keeping just the graphic quality essential to comprehend the situation.

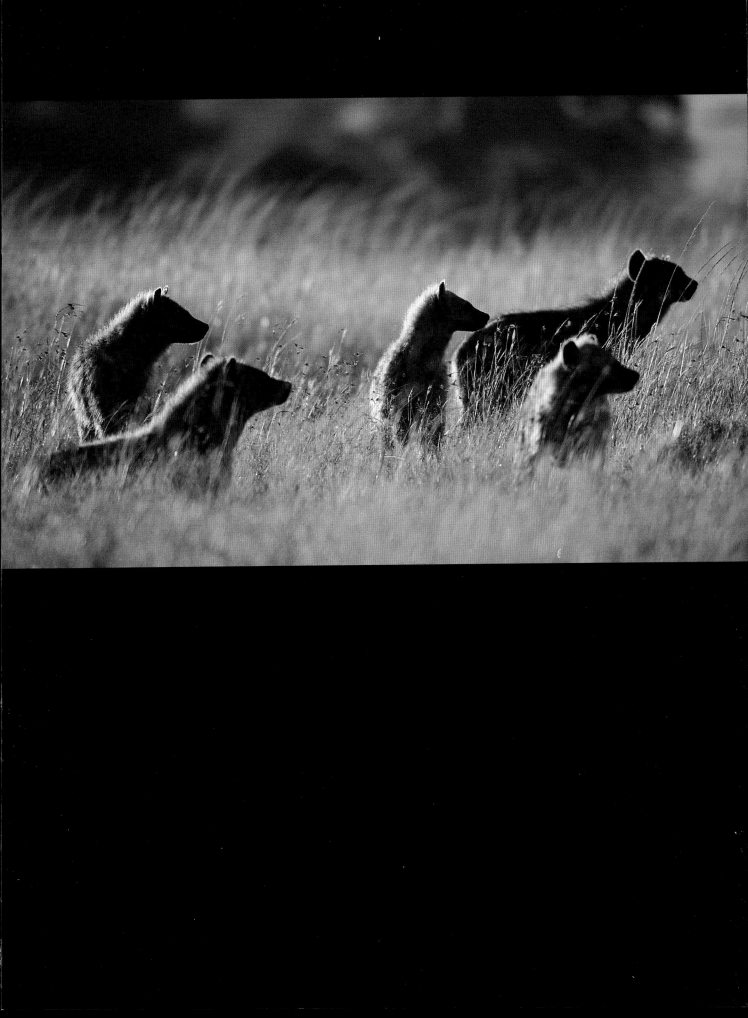

The north of Masai Mara is renowned as leopard country. But it will take repeated visits – to sometimes quite inaccessible sites – before you will be lucky enough to photograph this magnificent big cat. The rugged terrain it frequents does not always allow you to get very close, so a telephoto is indispensable to capture its fugitive image. Encounters are so rare, you may have to make do with dappled or dingy light rather than even lighting – but does this matter when the picture conveys the essence of this secretive predator?

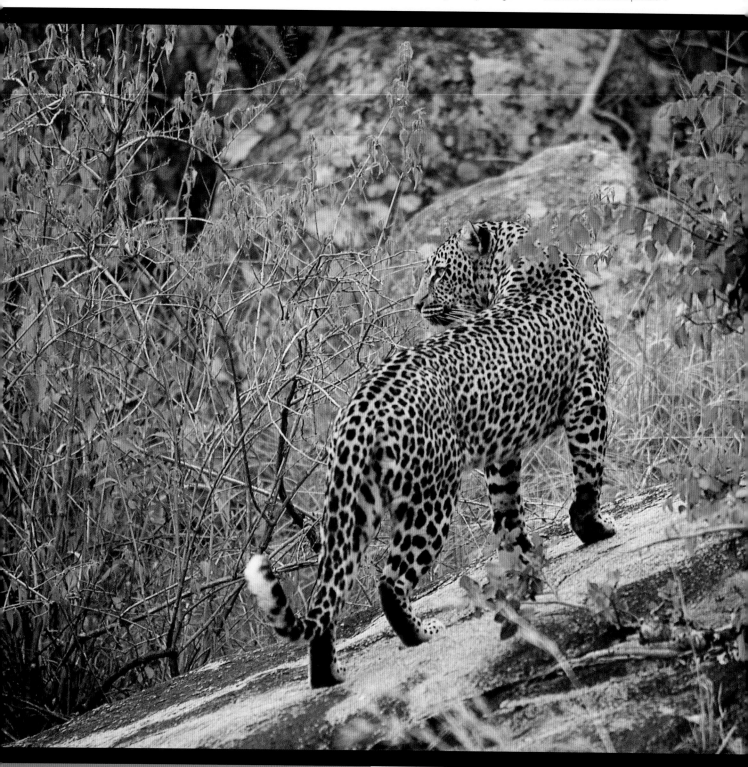

towards the steep uplands dotted with clumps of trees. Such trees shelter the nocturnal lesser bushbaby, whose strident cry cuts through the African night. Led by a matriarch, herds of elephants come here to seek food under the cover of the verdant branches, while the timid serval remains hidden near the edge, waiting to make a meal of the first rodent that passes by. These uplands form a transition zone into a rocky labyrinth of hills, where many rivers die only to be born again with the rains.

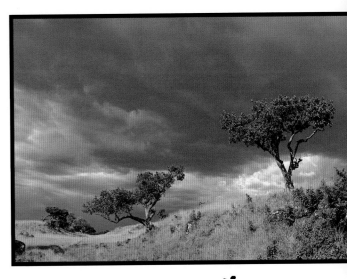

Even if you come back empty-handed from a search for the great spotted cat, the places it frequents are beautiful enough; bathed in a stormy light, they positively invite you to create new pictures. The use of a wide angle lens and a slightly upwards angle emphasises the enormousness of the stormy sky with this different view of the landscape.

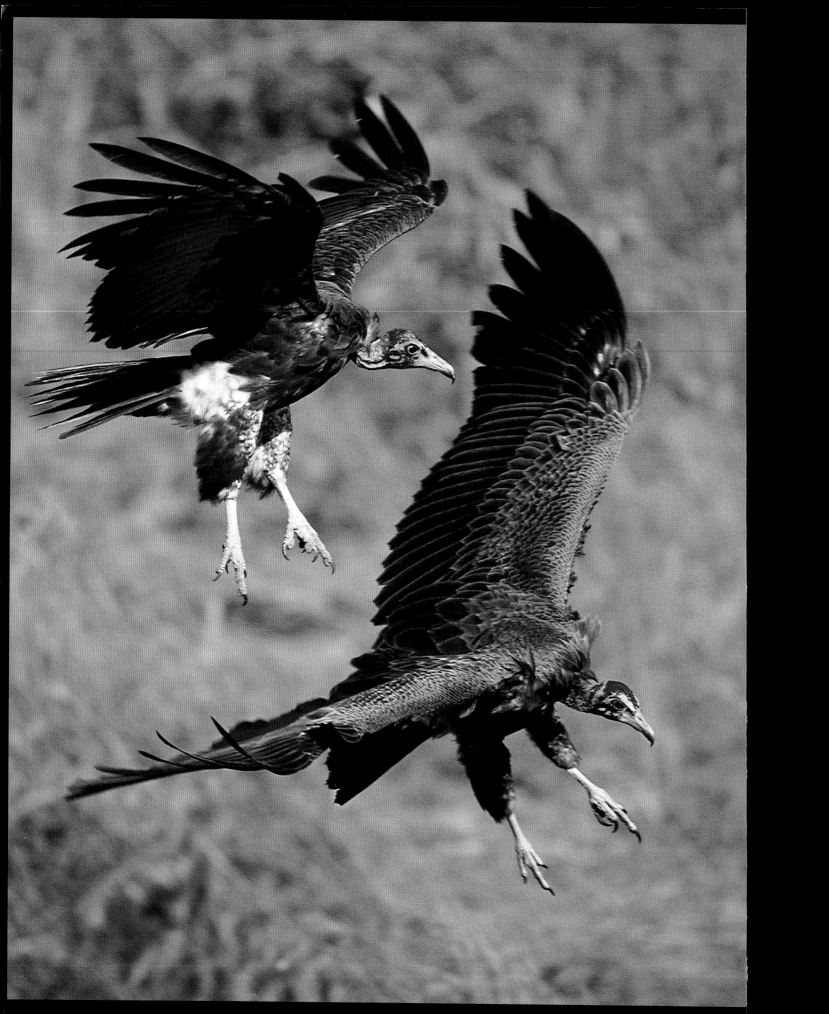

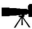

Whether you are shooting the male African paradise flycatcher, sporting long tail feathers in the breeding season; or the enormous ground hornbill, capable of seizing certain birds of prey; or the lilac-breasted roller, whose multicoloured livery makes it a constant subject of admiration – in all cases, the telephoto is the best tool for the bird photographer.

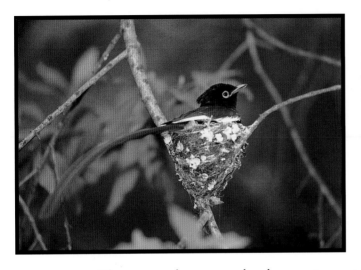

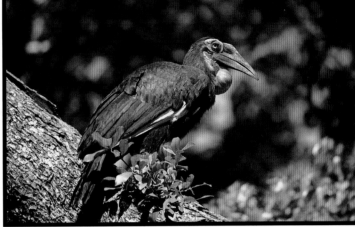

Their seasonal waters wind and intertwine through the rugged terrain dotted with bushes, dominated by the reddish hues of croton foliage. The territorial hyrax has settled here in a colony, to the great delight of the leopard, which particularly likes the larders formed by these grey rock islands. This habitat provides the animals with many lookouts and hiding-places, from which they can flee their enemies – most of the time. Such surroundings do not make it any easier to observe wildlife, but nonetheless make discovering it all the more exciting. The Masai Mara's world-wide reputation is certainly justified, not only for the beauty of its scenery, but above all for its immense wealth of fauna. Without doubt, no safari in Kenya should miss out this National Reserve and adjoining areas, which are likely to be the high-points.

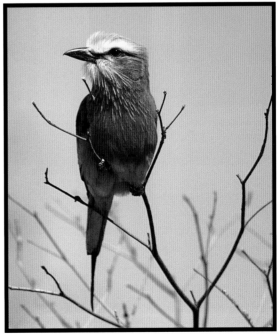

Hooded vultures are always the last to leave a carcass, probably because they are the last to gain access. Their slender beaks make it easier for them to tear off the smallest slivers of meat – eventually picking the bones clean. Though the hooded vultures are smaller than other scavenging birds of prey, the sight of them landing on a carcass with their outstretched talons is no less spectacular; a long lens allows tight framing of their aerial ballet.

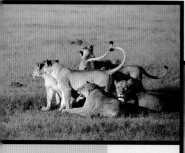

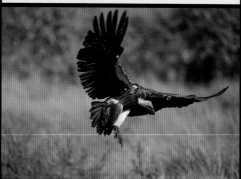

Practical tips

FORMALITIES
Valid passport (must be valid for at least six months beyond your return date). Visa obtained from the Embassy.

HEALTH
Yellow fever vaccination and anti-malarial treatment required. Water-purifying tablets can be useful.

LANGUAGES
Swahili and English. About 60 other dialects are also spoken.

CURRENCY
Kenyan shilling.

ELECTRICITY
240 volts.

TIME ZONE
GMT + 3 hours.

WEATHER
Hot and damp on the coast. Rather hot, dry temperate inland. Rains fall from March to June and in November/December with cooler, wetter weather on the higher ground. Moderate temperature variation between daytime and night-time, and from one season to another.

PHOTOGRAPHIC EQUIPMENT
Camera bodies, lenses, tripod or monopod, flashgun, films or memory cards, spare batteries, rechargeable batteries, bag to protect against dust, cleaning kit (blower, brush, soft cloth), beanbag (an excellent stabiliser for photographing through vehicle windows). A cigarette-lighter adaptor can be useful for recharging batteries. Memory cards should be offloaded daily onto a portable storage device. Take the time to work out the ratios between file size and number of images - so you can estimate your daily quota and avoid any risk of running out of card space in the field.

LUGGAGE
Clothing: light for the daytime: shirts, T-shirts, Bermuda shorts, shorts; warmer for early morning and evening: trousers, sweater or polar fleece jacket, lightweight jacket. Footwear: a pair of good, high-topped walking shoes and sturdy sandals for camp life. Other: hat, sunglasses, sunscreen, anti-mosquito lotion, torch, personal pharmacy, passport, plane ticket, credit card, and local currency in cash.

ACCOMMODATION
Kenya's particularly well-developed tourism infrastructure can hardly fail to leave you spoilt for choice. In theory at least, the numerous lodges offer a good standard of comfort, and there are also plenty of camps under canvas that allow you to get closer to nature. The roomy tents are usually pitched in very beautiful places: close to a river, on the edge of a forest facing towards an open plain, or perhaps on high ground overlooking the magnificent scenery. Most often these camps are unfenced, and as a result receive frequent nocturnal visits from animals. It is also possible to camp out within the Parks and Reserves. However, permission is required, and you are recommended to enlist the help of a specialist tour organiser. Camping in Africa is nothing like what we are used to in Europe. The presence of lots of wild animals in a confined area generates incessant activity that campers can appreciate even at night. But you will have to be content just to listen to the sounds of the bush, as it is extremely inadvisable to leave your tent. The experience is just as exciting and quite unforgettable!

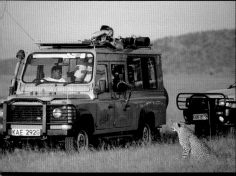

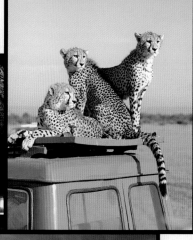

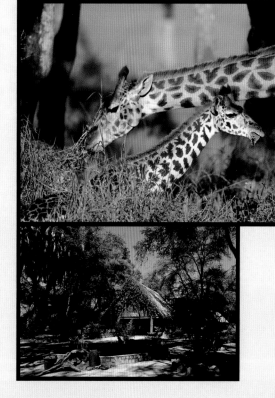

GETTING AROUND

The many trails in Kenya are generally well enough maintained to be driven in a minibus, a comfortable vehicle with ten or so seats, including a sunroof and sliding windows, and ideal for photography. But during and shortly after the rainy season the tracks are slippery and deeply rutted, so during these periods it is highly advisable to use a 4x4 vehicle. Most of these also have one or more openings in the roof. Although forbidden by the Park regulations, going off the track is a regular practice among safari drivers, always eager to satisfy their customers, who often ask to get as close as possible to the animals. Even though the creatures tolerate this disturbance, it is better to allow them space, especially if large cats want to hunt.

PARKS AND RESERVES

Kenya has around fifty National Parks and Reserves under the guardianship of the Ministry for Tourism and Wildlife. Together the National Parks total some four percent of Kenya's territory. The largest is Tsavo, which alone covers more than 20,000 square kilometres. The Reserves in total comprise 7.5

percent of the country's area; unlike the Parks, they accept the presence of humans and human activity, as long as it is compatible with the protection of the environment. The main protected areas are: Aberdare National Park, Amboseli National Park, Lake Bogoria National Reserve, Lake Nakuru National Park, Malindi National Marine Park, Marsabit National Reserve, Masai Mara National Reserve, Meru National Park, Mount Kenya National Park, Samburu National Reserve and the eastern and western Tsavo National Parks. The population of Kenya is growing at a fast pace, doubling every twenty years. So the inhabited areas are expanding and encroaching into the wildlife territories. These protected spaces, numerous but not large, are becoming veritable islands, encircled by human activity. Amongst the serious consequences of this situation is the destruction of certain habitats, as well as the absence of genetic mixing because it is becoming impossible for some species to breed with individuals from other regions. The pressure of tourism is also a factor in the threat to the ecosystems. Going to Kenya means not giving in to the temptation to put unnecessary

pressure on wildlife – as others still do, particularly going off-road to get closer to animals. It is far better to stay back and use a longer lens.

Wildlife photography

When you travel to a country like Kenya, it is important to get as much information as you can before you set off. Be sure to take adequate filmstock, or sufficient memory cards and a portable downloader. The size of an image file depends on the picture size and, depending on what you plan to do with your photos, for best quality you are recommended to save them in the largest format without excessive compression. For those who have the option, a daily edit of the shots taken is highly recommended. Be sure to bring plenty of batteries, or rechargeable ones with a charger, as there is no guarantee supplies will be available on site. Dust is the worst enemy of photographers, so make sure camera bags are dust- and shock-proof, with compartments to prevent bodies and lenses knocking. Also check up on safari times with your tour operator. More seasoned travellers – who have realised that the early morning and the end of the day offer the best light – will be disappointed to start travelling through the bush as late as 8 a.m. By this time, the equatorial sun is already high in the sky, and there is

precious little time left before the sunlight ceases caressing the animals with its gentle, orange warmth. Gone is the low-angle lighting that changes the shapes of the relief and flatters the colours of coats and plumage. Also, back-lighting for making rimlit silhouettes is lost until the end of the day.

Backlit shots are best achieved using a long lens – depending on the distance from the subject it may be between 300 and 600 mm. This type of telephoto allows close-ups and will prove indispensable not just for photographing birds, but also for bringing back good shots of the big animals. At wide aperture, they cope well with converters and doublers. But their usefulness should not make us overlook the shorter lenses. An 80-200 mm zoom, for example, offers a great variety of composition – placing an animal in its context, including several individuals, picking out a detail of the setting. The spectacular sunrises and sunsets are a good opportunity to use a wide angle, perfect for rendering all the pink, orange, red, dark blue or purple nuances of the sky at these key moments of the day. In every situation, it is advisable to have at least two camera bodies available, for when a fast, interesting scene unfolds, it means you can try different picture compositions without having to waste time changing lenses and risk missing part of the action or getting dust on the sensor of a digital camera.

There are a few places in Kenya's Parks and Reserves where you can get around on foot, especially around the lakes. Here it is useful to carry a monopod or tripod. But most of the time, safety rules mean you have to stay within the vehicles, not only to avoid disturbing the wildlife, but also to avoid the risk of being

attacked. A beanbag (or tough cloth bag filled with dried peas or rice) is essential for wedging your camera firmly on the edges of the windows or sunroof, especially when using heavy, longlenses. Three-quarters filled, the beanbag ensures good stability and makes it possible to use even quite slow shutter speeds, as long as you can hold your breath and make sure the vehicle's engine is stopped, to avoid vibration. This latter point is applicable at any time of day.

Having taken all these elements into account, all that remains is to concentrate on observing the fascinating African fauna and the sublime landscapes that are its home. Patience and determination are indispensable qualities for anyone who hopes to watch scenes and behaviour such as we see in the cinema and on television. Patient waiting is an essential quality of the greatest wildlife film-makers and photographers; waiting for the right light, in the right spot, on the right subject in the right pose. For example, watch for the glint of the sunlight in the eyes of a cheetah stretched out on a stone slab, turn your back on the storm, or release the shutter at the very moment the bateleur eagle takes off.

Waiting, as well as curiosity, is the price photographers – amateur or professional – have to pay to reap the rewards of memorable pictures. They need to know how to scrutinise their surroundings, to learn to know them, and familiarise themselves with the silhouettes of flora and fauna in order to better dream up new graphic ideas, to make their images even better. The photograph is a testimony. It may also be a creation. There are reporters and there are artists – and sometimes they are one and the same. It is all a question of sensitivity.